Futurism: A Very Short Introduction

VERY SHORT INTRODUCTIONS are for anyone wanting a stimulating and accessible way into a new subject. They are written by experts, and have been translated into more than 45 different languages.

The series began in 1995, and now covers a wide variety of topics in every discipline. The VSI library currently contains over 750 volumes—a Very Short Introduction to everything from Psychology and Philosophy of Science to American History and Relativity—and continues to grow in every subject area.

Very Short Introductions available now:

ANALYTIC PHILOSOPHY Michael Beaney
ANARCHISM Alex Prichard
ANCIENT ASSYRIA Karen Radner
ANCIENT EGYPT Ian Shaw
ANCIENT EGYPTIAN ART AND ARCHITECTURE Christina Riggs
ANCIENT GREECE Paul Cartledge
ANCIENT GREEK AND ROMAN SCIENCE Liba Taub
THE ANCIENT NEAR EAST Amanda H. Podany
ANCIENT PHILOSOPHY Julia Annas
ANCIENT WARFARE Harry Sidebottom
ANGELS David Albert Jones
ANGLICANISM Mark Chapman
THE ANGLO-SAXON AGE John Blair
ANIMAL BEHAVIOUR Tristram D. Wyatt
THE ANIMAL KINGDOM Peter Holland
ANIMAL RIGHTS David DeGrazia
ANSELM Thomas Williams
THE ANTARCTIC Klaus Dodds
ANTHROPOCENE Erle C. Ellis
ANTISEMITISM Steven Beller
ANXIETY Daniel Freeman and Jason Freeman
THE APOCRYPHAL GOSPELS Paul Foster
APPLIED MATHEMATICS Alain Goriely
THOMAS AQUINAS Fergus Kerr
ARBITRATION Thomas Schultz and Thomas Grant
ARCHAEOLOGY Paul Bahn
ARCHITECTURE Andrew Ballantyne
THE ARCTIC Klaus Dodds and Jamie Woodward
HANNAH ARENDT Dana Villa
ARISTOCRACY William Doyle
ARISTOTLE Jonathan Barnes
ART HISTORY Dana Arnold
ART THEORY Cynthia Freeland
ARTIFICIAL INTELLIGENCE Margaret A. Boden
ASIAN AMERICAN HISTORY Madeline Y. Hsu
ASTROBIOLOGY David C. Catling

ASTROPHYSICS James Binney
ATHEISM Julian Baggini
THE ATMOSPHERE Paul I. Palmer
AUGUSTINE Henry Chadwick
JANE AUSTEN Tom Keymer
AUSTRALIA Kenneth Morgan
AUTHORITARIANISM James Loxton
AUTISM Uta Frith
AUTOBIOGRAPHY Laura Marcus
THE AVANT GARDE David Cottington
THE AZTECS Davíd Carrasco
BABYLONIA Trevor Bryce
BACTERIA Sebastian G. B. Amyes
BANKING John Goddard and John O. S. Wilson
BARTHES Jonathan Culler
THE BEATS David Sterritt
BEAUTY Roger Scruton
LUDWIG VAN BEETHOVEN Mark Evan Bonds
BEHAVIOURAL ECONOMICS Michelle Baddeley
BESTSELLERS John Sutherland
THE BIBLE John Riches
BIBLICAL ARCHAEOLOGY Eric H. Cline
BIG DATA Dawn E. Holmes
BIOCHEMISTRY Mark Lorch
BIODIVERSITY CONSERVATION David Macdonald
BIOGEOGRAPHY Mark V. Lomolino
BIOGRAPHY Hermione Lee
BIOMETRICS Michael Fairhurst
ELIZABETH BISHOP Jonathan F. S. Post
BLACK HOLES Katherine Blundell
BLASPHEMY Yvonne Sherwood
BLOOD Chris Cooper
THE BLUES Elijah Wald
THE BODY Chris Shilling
THE BOHEMIANS David Weir
NIELS BOHR J. L. Heilbron
THE BOOK OF COMMON PRAYER Brian Cummings
THE BOOK OF MORMON Terryl Givens
BORDERS Alexander C. Diener and Joshua Hagen
THE BRAIN Michael O'Shea
BRANDING Robert Jones

TWENTIETH-CENTURY BRITAIN
 Kenneth O. Morgan
TYPOGRAPHY Paul Luna
THE UNITED NATIONS
 Jussi M. Hanhimäki
UNIVERSITIES AND COLLEGES
 David Palfreyman and Paul Temple
THE U.S. CIVIL WAR Louis P. Masur
THE U.S. CONGRESS Donald A. Ritchie
THE U.S. CONSTITUTION
 David J. Bodenhamer
THE U.S. SUPREME COURT
 Linda Greenhouse
UTILITARIANISM
 Katarzyna de Lazari-Radek and
 Peter Singer
UTOPIANISM Lyman Tower Sargent
VATICAN II Shaun Blanchard and
 Stephen Bullivant
VETERINARY SCIENCE James Yeates
THE VICTORIANS Martin Hewitt
THE VIKINGS Julian D. Richards
VIOLENCE Philip Dwyer
THE VIRGIN MARY
 Mary Joan Winn Leith
THE VIRTUES Craig A. Boyd and
 Kevin Timpe

VIRUSES Dorothy H. Crawford
VOLCANOES Michael J. Branney and
 Jan Zalasiewicz
VOLTAIRE Nicholas Cronk
WAR AND RELIGION Jolyon Mitchell
 and Joshua Rey
WAR AND TECHNOLOGY
 Alex Roland
WATER John Finney
WAVES Mike Goldsmith
WEATHER Storm Dunlop
SIMONE WEIL
 A. Rebecca Rozelle-Stone
THE WELFARE STATE David Garland
WITCHCRAFT Malcolm Gaskill
WITTGENSTEIN A. C. Grayling
WORK Stephen Fineman
WORLD MUSIC Philip Bohlman
WORLD MYTHOLOGY
 David Leeming
THE WORLD TRADE
 ORGANIZATION Amrita Narlikar
WORLD WAR II Gerhard L. Weinberg
WRITING AND SCRIPT
 Andrew Robinson
ZIONISM Michael Stanislawski
ÉMILE ZOLA Brian Nelson

Available soon:

For more information visit our website

www.oup.com/vsi/

Ara H. Merjian

FUTURISM

A Very Short Introduction

Great Clarendon Street, Oxford, OX2 6DP,
United Kingdom

Oxford University Press is a department of the University of Oxford.
It furthers the University's objective of excellence in research, scholarship,
and education by publishing worldwide. Oxford is a registered trade mark of
Oxford University Press in the UK and in certain other countries

© Ara H. Merjian 2025

The moral rights of the author have been asserted

All rights reserved. No part of this publication may be reproduced, stored in a retrieval system,
transmitted, used for text and data mining, or used for training artificial intelligence, in any form or
by any means, without the prior permission in writing of Oxford University Press, or as expressly
permitted by law, by licence or under terms agreed with the appropriate reprographics rights
organization. Enquiries concerning reproduction outside the scope of the above should be sent
to the Rights Department, Oxford University Press, at the address above.

You must not circulate this work in any other form
and you must impose this same condition on any acquirer

Published in the United States of America by Oxford University Press
198 Madison Avenue, New York, NY 10016, United States of America

British Library Cataloguing in Publication Data
Data available

Library of Congress Control Number: 2024942651

ISBN 9780192871008

DOI: 10.1093/9780191967337.001.0001

Printed and bound by
CPI Group (UK) Ltd, Croydon, CR0 4YY

Links to third party websites are provided by Oxford in good faith and
for information only. Oxford disclaims any responsibility for the materials
contained in any third party website referenced in this work.

The manufacturer's authorised representative in the EU for product safety is Oxford University
Press España S.A. of El Parque Empresarial San Fernando de Henares, Avenida de Castilla,
2 – 28830 Madrid (www.oup.es/en or product.safety@oup.com). OUP España S.A. also acts as
importer into Spain of products made by the manufacturer.

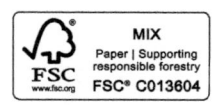

Contents

Acknowledgments

I would like first and foremost to thank Latha Menon for being such an attentive and encouraging editor; it has been a genuine pleasure to collaborate with her from start to finish. Thanks also to Imogene Haslam and Kripa Prabhakar for their editorial assistance. Three anonymous readers helped to make the volume stronger; whatever errors remain are mine alone. I express my gratitude to Layden Kennedy and Stella Magni for their editorial and indexing assistance. Finally, I am grateful for the good cheer and always stimulating conversation—on Futurism and other matters—of Stefano Albertini, Mark Antliff, Pierpaolo Antonello, Maria Luisa Ardizzone, Rafaelle Bedarida, Willard Bohn, Laura Cecchini, Stefano Chiodi, Luca Cottini, Roberto Dulio, Alessandro Giammei, Sharon Hecker, Nicola Lucchi, Tommaso Mozzatti, Elena Pontiggia, Karen Raizen, Lucia Re, Jane Tylus, Claudia Salaris, and Anthony White.

List of illustrations

Futurism

Chapter 1
"Synthetic brevity"

"It's stupid to write a hundred pages when just one would do."

Thus averred Filippo Tommaso Marinetti a few years after founding Italian Futurism in 1909. However unwittingly, he heralded the very premise of the *Very Short Introduction*. Marinetti's Futurist movement championed what he called "synthetic brevity." "Condense all of Shakespeare into a single act," he demanded in one notable example. His disgust for "detailed analyses and explanations" was tempered only by a "love of speed, abbreviation, and synopsis."

Such concision derived in part from Friedrich Nietzsche's pledge to philosophical pith: "It is my ambition to say in ten sentences what everyone else says in a whole book." Nietzsche's own oracular fragments attracted not merely students of the past but "architects of the future"; his earliest Italian devotee, the poet and orator Gabriele D'Annunzio, styled himself an ultranationalist *Übermensch* who aimed to revive Italy's millennial greatness. Yet even these philosophical heresies appeared "passé" to the Futurists, along with the whole of European—and especially Italian—heritage.

Notwithstanding Marinetti's cultural origins in 19th-century literature, art, and thought, he aimed to defy the authority of

origins altogether. Italy's patrimony represented for the Futurists not a boon to contemporary creativity, but its chief liability. Fully incorporated and independent only since 1871—a decidedly young nation—Italy had yet to forge an identity to match its "resurgence" as a modern state. Roman antiquity and Renaissance glory remained its chief cultural currencies. The French statesman Lamartine had dubbed Italy the "land of the dead," while James Joyce wrote back to his brother from Rome that the city reminded him "of a man who lives by exhibiting his grandmother's corpse."

The Futurists internalized and hyperbolized these appraisals. They railed against "the museums and cemeteries of mummified syllogisms"; they vowed "to destroy museums, libraries, academies of every sort." In countless manifestos, they launched the epithet "*passéiste*" against a growing set of aesthetic and literary taboos: a love of the picturesque, of Romantic solitude and nostalgia, of "superficial and elementary archaism." Only the obliteration of tradition—and its wholesale substitution by modern technologies, media, and metaphors—would drag a still largely agrarian Italy into the 20th century.

Disdain for the cultural past—like the fetishization of some idealized future—was nothing new. The French Impressionist painter Camille Pissarro had long since called for the Louvre to be burned down in order to foster more modern artistic sensibilities; conversely, the novelists Jules Verne and H. G. Wells had envisioned entire worlds transformed by technological marvels. Futurism's chief novelty lay neither in visual style (borrowed first from post-Impressionism and then from Cubism) nor subject matter. What it originated instead was a comprehensive fusion of aesthetics and ideology—a "Futurist Reconstruction of the Universe" as one key manifesto put it.

For all its professed contempt for the past, Futurism left a more enduring mark than perhaps any other avant-garde of the 20th century—precisely in its creative disdain for immortalization.

Marinetti's "Founding and Manifesto of Futurism" (Figure 1) anticipated the movement's demise even before he had recruited fellow authors and artists to the movement's cause. "When we are forty, others who are younger and stronger will throw us into the

1. **F. T. Marinetti, "The Founding and Manifesto of Futurism,"** *Le Figaro*, **February 20, 1909.**

wastebasket, like useless manuscripts—We want it to happen!"
Antonio Sant'Elia declares of Futurist architecture in 1914 that its
chief characteristics must be transience and impermanence:
"Every generation will have to make its own city anew." Futurism's
ceaseless flow of birth announcements—manifestos on everything
from architecture to music, dance to food—doubled as invitations
to its imminent funeral.

These documents now embody the old news they derided. They
appear exhibited in museum cases like prized sheets of ancient
papyrus, yellowed and delicate. There thus obtains a special irony
in historicizing a phenomenon staked upon willful oblivion. What
happens to Futurism when, having denounced "the cult of the
past" and likened the admiration of "old paintings" to necrophilia,
its objects become artifacts of study in turn? "Down with gouty
academies and ignorant professors!" railed the Futurist painters in
1910. "Every day we must spit on the Altar of Art," insisted
Marinetti's "Technical Manifesto of Futurist Literature" (1912),
which called for the destruction of syntax and punctuation, along
with the hidebound states of mind they preserve and perpetuate.

Futurist writing never wholly renounced syntactical propriety, just
as its artists never abjured completely the cultural capital of
painting and sculpture. Futurist formal strategies upended the
encrusted habits of traditional aesthetics. Yet its artists—quite
unlike the Dadaists they inspired—never truly undermined the
commercial, ontological, or even spiritual import of their works.
"Nothing is more terrible than art, there is only art," declared
Umberto Boccioni—the group's leading artist and chief
theorist—on the eve of his untimely death during World War I.

It was in part the assimilation of war itself to the precincts of
aesthetics that set Futurism apart. Yet they also understood their
visual and verbal production as bound up with the same crusade.
Rather than hang as passive objects of contemplation, Futurist
paintings would thrust spectators into the center of pictorial

space; performances would oblige active participation in their multimedia frenzy; the belligerence of Futurist language would materialize in actual fisticuffs and physical violence. Futurist "*art-action*" extended from gallery walls to city streets to the political realm, where it aimed to shake up parliamentary liberalism to the same degree as aesthetic convention. It extended, too, to the waging of actual war. Having agitated ceaselessly for Italy's alliance with the Entente powers, Marinetti and many of his confrères served eagerly on the front lines of world war—a cataclysm he notoriously deemed "the finest Futurist poem." Art was no longer to be a phenomenon separate from life. It thus also comprised technologies of death, in the service of an ostensibly rejuvenated Italy.

The Futurist rhetoric of youth and virility lent enormous impetus to Benito Mussolini's Fascist revolution. Marinetti contributed practical assistance as well, serving on the central committee of the *Fasci di combattimento* after its founding in March 1919 and helping to shape the party's early electoral platform. As Fascism transitioned from movement to regime after 1922, Marinetti expected generous returns on his ideological investment. This was not to be. Early Futurist ideals—abolition of the monarchy and Papacy, equal pay for women, and steep taxation on wealth, among others—gave way to hardline Fascist stances aimed to shore up the support of big business, the bourgeoisie, and even the Vatican. Mussolini also refused to name Futurism, or indeed any group, the official state art. As ancient Rome (and the legacies of its empire) mounted in contemporary relevance for Fascist culture, Futurism's star waned. Rapports with government bureaucracy proved strained.

Even still, Futurism's adherents swelled in number between the world wars. A slew of young artists relaunched the movement with new experiments, some innovative and others hopelessly derivative. Whatever Marinetti's private objections to Fascism's conservative turn, he never relented in his public campaigns on its

behalf. He deigned even to become a "gouty academic" in his turn, donning the pompous threads of the Fascist *Accademia* in 1929. Ever as faithful to his gun as to his pen, Marinetti would follow the regime on its imperialist conquests in Africa and in yet another world war; volunteering first in the brutal Ethiopian campaigns of 1936, he served thereafter in Italy's battalions on the eastern front in 1942. From the movement's heady start to its pathetic end, bellicosity remained the crux of Marinetti's crusade in word and deed alike.

Yet, just as Futurism is not the same as Fascism, the movement's legacy is not reducible to Marinetti's biography. Men and women from a range of social backgrounds and political orientations contributed to its experiments. From the anarcho-syndicalist origins of many early members, to attempted syntheses by various artists of Futurism and Communism after World War I, to a host of apolitical enthusiasts and opportunist hangers-on, the multiplicity of Futurist ranks refuse any neat ideological taxonomy.

A phenomenon as widespread and enduring as Futurism— outlasting Dada, Constructivism, the Bauhaus, and nearly every other "historical" avant-garde it influenced in one way or another—is bound to be shot through with all manner of incongruities. One of its many paradoxes is a vast international resonance in the teeth of its own virulent nationalism. Marinetti's flair (and funds) for publicity rendered Futurism the first truly international avant-garde. From the launching of Russian, Japanese, Armenian, and Portuguese Futurisms in the early 1910s, to related groups like Zenitism, Stridentism, and Ultraism, its influence was unparalleled, even—or especially—when taken in new directions by rivals and successors. Marinetti claimed all of these tendencies as offshoots of Futurist primacy.

Even his chauvinism conceals a glimmer of truth. "The Futurist moment," writes literary critic Renato Poggioli, "belongs to all the

avant-gardes and not only to the one named for it." Indeed, the term has long since come to signal a range of modernist phenomena—and a general sensibility—transcending Marinetti's particular movement. Despite a rhetorical wish for cultural oblivion, Futurism persists as the paradigm—and the unconscious—of 20th-century avant-gardism at large: an ideological crusade as much as an artistic project; a relentless assault upon the boundaries separating art from life; a drive for some invigorating futurity greater than the sum of its aesthetic and ideological parts.

Those parts, in the case of Italian Futurism, are legion. Countless pamphlets, manifestos, leaflets, and tracts suggest anything but the "synthetic brevity" vaunted by Marinetti. In what follows, I nevertheless attempt ("academic gout" be damned!) to introduce and to synthesize the movement's origins, development, and afterlife. Though the book's chapters proceed in rough chronological order, they may also be read separately; their thematic cast aims to lend some synchronic sense to interrelated phenomena.

Chapter 2
"Primitives of a new sensibility"

A curious text greeted readers of the Parisian *Le Figaro* on February 20, 1909 (Figure 1). Down its front page unfurled words of "burning and overwhelming violence." By turns playful and confrontational, a manifesto of "Futurism" announced the imminent demolition of Italy's cultural patrimony: art and architectural wonders no longer to be revered but instead razed forthwith.

> For much too long Italy has been a flea market. We intend to liberate it from the countless museums that have covered it like so many cemeteries...Go ahead! Set fire to the shelves of the libraries!...Turn aside the course of the canals to flood the museums!...Oh, the joy of seeing all the glorious old canvases floating adrift on the waters, shredded and discolored!...Seize your pickaxes, axes, and hammers, and tear down, pitilessly tear down the venerable cities!

From the motorcar to the radio, the X-ray to the airplane, modern technology had radically transformed Western urban life by the first decade of the 20th century. New perceptions of time and space emerged in tandem with the (ever more interconnected) mass cultures of major cities. Such changes upended not only narrative strategies and visual representations, but also the psychic states

2. F. T. Marinetti in his four-cylinder Fiat, 1908.

they both depicted and incited. As one of Western Europe's least industrialized countries, Italy appeared impervious to such developments. With the exception of a few industrial clusters in the north, it remained a fundamentally agrarian nation. Even decades after its belated unification in the late 19th century, the country lacked any truly modern cultural identity. It was this state of affairs at which the "Founding and Manifesto of Futurism" took aim.

Its first-person plural belied a collective of one. For the text issued from a single individual: the poet, impresario, and firebrand F. T. Marinetti (Figure 2). His piece had appeared weeks earlier in papers in Naples and Emilia Romagna, where it went largely unremarked. A far wider audience greeted its dissemination in Paris—Europe's undisputed cultural capital. Marinetti nevertheless hastened to stress its national origins and intentions: "It is from Italy that we are flinging this to the world."

No such "we" existed at the time of writing. Marinetti nevertheless quickly attracted a cadre of young Italian artists and authors to

the Futurist fold: the painters Umberto Boccioni, Carlo Carrà, Luigi Russolo, and Gino Severini, joined thereafter by Giacomo Balla, Paolo Buzzi, Fortunato Depero, and a number of prominent Florentine avant-gardists. As a poet, playwright, novelist, editor, and polemicist, Marinetti embodied the interdisciplinarity fundamental to Futurism, which in just a few years swelled to include dancers and musicians, architects and photographers, set designers and cinematographers. From its base in Milan, Futurist activity spread throughout the entire peninsula, while related movements emerged almost immediately in Moscow and Lisbon, Tbilisi and Tokyo.

Marinetti's cultural campaign began as a lone enterprise, however. And its agenda appeared polished before a single Futurist poem had been penned or canvas painted.

Futurism's founding tract teems with words in advance of deeds. It fulminates and anticipates, abjures and avows. A quirky narrative prologue details the author's recent automobile crash into a factory drain full of industrial by-product—the consummately modern circumstance of his Futurist rebirth and ensuing evangelism. The "good news" Marinetti set about spreading was not limited to personal revelation, however. His ambition comprised the widest possible scope, synthesized in 11 objectives:

1. We intend to sing to the love of danger, the habit of energy and fearlessness.

2. Courage, boldness, and rebelliousness will be the essential elements of our poetry.

3. Up to now literature has exalted contemplative stillness, ecstasy, and sleep. We intend to exalt movement and aggression, feverish insomnia, the racer's stride, the mortal leap, the slap and the punch.

4. We affirm that the beauty of the world has been enriched by a new form of beauty: the beauty of speed. A racing car with a hood that glistens with large pipes resembling a serpent with explosive

breath, a roaring automobile that seems to ride on grapeshot—
that is more beautiful than the Victory of Samothrace....

The manifesto pulls no proverbial punches. Indeed, Marinetti
intended for language itself now to embody the slap and the
punch—to shed, that is, its literary passivity for action.

Later Futurist texts would employ typographic modifications to
those ends, accentuating and animating the very surface of the
page. Futurist painting, poetry, and sculpture likewise came to
evoke dynamism not merely by way of subject matter (striding
bodies, speeding machines), but formal and verbal agitation. The
artists were not content simply to publish their "Manifesto of
Futurist Painters" in March 1910, for instance; they took to the
stage of the Teatro Chiarella in Turin a week later to declaim it
aloud, dodging vegetables and insults from the crowd and
responding in kind. Printed the same year as his founding
manifesto, Marinetti's *Mafarka the Futurist: An African Novel*
(1909) saw him taken to court for offending public morals.
Thanks to three highly publicized trials, the novel's self-professed
"polyphony" came to comprise even juridical process and
exoneration, lifting its fictional heroics off the page and into
real time.

Yet Marinetti's first manifesto already evokes Futurist ideas as
something to be performed as much as communicated. Among its
early avowals we may discern a few recurring themes: a rapture
for machine-propelled speed and its salutary hazards; the
exchange of past cultural idols for modern, mechanized spectacle;
the revitalization of all aesthetic expression by "movement and
aggression."

As we will see in the pages that follow, that aggression proved
more than metaphorical. Futurism made good on some of the
manifesto's less benevolent intentions, most notoriously the
glorification of war as "the only hygiene of the world." Signifying

an army's scouting vanguard, the French term "avant-garde" originated in military circles. Marinetti and other artists made that martial sense literal, volunteering for a Futurist battalion on Italy's northern front during World War I. Many devotees would live out (or die for) the Futurist dedication to "art-action" up through Mussolini's brutal African empire and a second world war. Marinetti's accommodations with the Fascist regime after 1922—through the 1935 invasion of Ethiopia and even the Racial Laws of 1938—seemingly confirmed his early assertion that art "can be nothing if not violence, cruelty, and injustice." Prefiguring and then propagandizing Fascist nationalism and imperialism, the "activist model" of the Futurist avant-garde remains—more than a century later—deeply fraught in its historical implications, for that same activism also drove the movement's more progressive dimensions. Integral to its very development, Futurism's political impetus proved relentlessly paradoxical in origin and upshot.

Though a more recent phenomenon than counterparts in England or France, the Italian middle classes already bore their own cultural baggage. Like other avant-garde groups that followed, the Futurists assailed the trappings of bourgeois propriety. Yet they also scrambled the traditional coordinates of conservatism and revolution, right and left. The Futurist drive to rejuvenate Italy proved as rabidly anti-socialist as it was anti-bourgeois, merging anarchist revolt with a disdain for egalitarianism.

Most of the early group frequented anarchist and syndicalist circles, and in the spring of 1911 participated in a "Free Art" exhibition for working men and their families in Milan. Influenced by the political theories of Georges Sorel, Futurist sympathy for a "revolutionary proletariat" increasingly absorbed nationalist and irredentist elements, subordinating the insurgency of organized labor to the primacy of nation, war, and empire. Marinetti would even found the Futurist Political Party by 1918; alongside the incitement to "revolutionary nationalism," its platform vowed to tackle illiteracy, legalize divorce, reform labor

laws, abolish the secret police, and eliminate the "medieval theocracy" of clericalism. In short, Futurism amounted to far more than the art movement to which it remains reduced in many retrospectives and academic studies. Its ideological origins, furthermore, are not reducible to simple soundbites.

Crucially, the same ideology permeated even Futurism's nominally aesthetic imperatives. "Art with a capital A is a form of intellectual clericalism," Marinetti declares in his 1913 manifesto, "Destruction of Syntax/Words-in Freedom." His phrasing tellingly conflates social conservatism and aesthetic convention. With regard to the latter, only a ruthless purge would clear a path to the future. Into the Tiber river would go Roman and Renaissance treasures— impediments to everything original and inventive. Banished, too, were the fin-de-siècle lyricisms that merely sentimentalized former glories while smothering *contemporary* Italian "genius."

Marinetti himself was no stranger to late Romantic lyricisms; his nationalist fervor, moreover, stemmed at least in part from a foreignness to Italy's shores. Born to wealthy Italian parents in Alexandria, Egypt, he studied at the city's French Jesuit *lycée*, where a penchant for the novels of Émile Zola nearly got him expelled. Though he took a law degree from the University of Pavia, it was French literature that held him in thrall after a *baccalauréat* at the Sorbonne. Symbolist poets from Baudelaire to Mallarmé influenced his early verse, which he promoted in Paris and Milan, founding (and funding) the journal *Poesia* in the latter city by 1905. The journal published francophone luminaries like Gustave Kahn and Émile Verhaeren alongside emerging Italian poets. *Poesia* also served as a clearing house for Marinetti's own multiplying endeavors, from reviews of his satirical play *Le Roi Bombance* (1905) to the earliest Futurist manifestos.

From Marx and Engels's Communist Manifesto (1848) to Jean Moréas's manifesto of Symbolist literature (1886), manifestos had emerged in the late 19th century as instruments of political or

aesthetic declaration. Marinetti was the first to synthesize those drives in a nearly autonomous genre—what he called "the art of making manifestos." By 1915 there circulated several dozen Futurist proclamations on everything from men's clothing to set design to "lust." In title and content alike, Giacomo Balla and Fortunato Depero's 1915 manifesto "The Futurist Reconstruction of the Universe" (1915) epitomized the movement's self-styling as both unequivocally new and uniquely Italian: "The discoveries contained in this manifesto are absolute creations, completely generated by Italian Futurism. No artist before us, whether in England, France, Germany, or Russia, has discovered something similar or analogous."

Yet Futurism bore a host of precursors, even in name. The Catalan author Gabriel Alomar had published a tract titled *El futurisme* in 1904; though focused chiefly on political economy, its reception in the French press likely caught Marinetti's attention. The latter briefly considered calling his movement "Electricism" or "Dynamism." But neither term captured the kind of *historical* rupture Marinetti aimed to signal, under whose aegis any and every expression might count as forward-looking. Disparate precedents nevertheless filtered into Futurism's *tabula rasa*: the breathlessly "electric" and embodied verse of Walt Whitman; the irreverent avant-gardism of Alfred Jarry's *Ubu* plays; the collective urban poetics of Jules Romains's Unanimism—to name only the most salient.

Even more influential were the writings of Henri Bergson and Friedrich Nietzsche, whose respective deconstructions of 19th-century positivism lent Futurism a potent philosophical substratum. In theory, the movement disavowed the life of the mind for the physicality of the body. "We violently reject Nietzsche's ideals," Marinetti railed, dismissing the philosopher as "begat from the dust of libraries." Still, any examination of Futurist texts or images reveals the mark not only of vitalist concepts like the will to power and the *Übermensch*, but also Nietzsche's

proposed "transvaluation of all values." The demotion of intelligence in favor of creative intuition echoed even more consequentially in Bergson's writings, which significantly shaped Futurist theories of time, duration, and flux.

The unprecedented flux of modern urban life already appeared palpable in the most advanced (read: French) painting of the day. The experience of modernity, the poet Charles Baudelaire famously declared, entailed "the transient, the fleeting, the contingent." Evoking the apperceptions of a "mobile spectator" (in the words of the art historian Meyer Schapiro), Impressionism dissolved encrusted representational conventions like perspective and chiaroscuro, incorporating into painting the very contingencies of seeing: light, weather, time of day. Impressionism's subjects were no longer predetermined by literary or historical models. Whether an anonymous drinker in his cups or a prostitute on the boulevard, the steam from a train or a thronged café-concert, it was everyday urban life which guided the Impressionist brush. Marinetti pledged Futurism to evoke the "great stirring crowds" of the "modern metropolis." Its painters duly recognized their debts to Impressionism in this regard, vowing "recourse only to Nature and not to the Museum!" Emerging as the group's chief theorist, Boccioni further affirmed that "painting cannot exist today without Divisionism." The division of color (whence the post-Impressionist tendency's name) into tiny flecks of pigment evoked a world continually coming into being, never fixed or static—an impermanence with more than merely formal implications for Futurism.

An older generation of modern Italian artists—Giovanni Segantini, Giuseppe Pellizza da Volpedo, and Gaetano Previati— had assimilated these techniques and merged them with both Symbolist and socialist motifs. Their work greatly influenced Futurism's first efforts, particularly as challenges to the academic and political establishments. By the century's turn, Giacomo Balla—the oldest member of the core Futurist group—applied

both Divisionism and its leftist penchants to paintings like *Bankrupt* (1902) and *The Worker's Day* (1904). Made shortly after Futurism's founding, his *Street Lamp* (1909) (Figure 3) exemplifies the movement's early strategies. The splintered flicker of its electric lamp outshines a wan crescent moon, echoing Marinetti's call this same year to "murder the moonlight"—that is, to replace Romantic platitudes with wholly modern phenomena. Balla's students Severini and Boccioni both took up post-Impressionist techniques in turn, though only the latter set them to discernibly sociopolitical ends. A working-class neighborhood on Milan's industrial outskirts pulsates with Divisionist light and color in Boccioni's *Factories at Porta Romana* (1909). An unpaved road leads the viewer's gaze deep into the picture plane alongside workers setting out toward smoking chimneys in a prospect abuzz with expectation.

Expectation turns to productive tumult in Boccioni's *The City Rises* (1910) (Figure 4), measuring two by three meters and originally exhibited under the title *Work*. Framed by factory smokestacks and a building under construction (an icon of the Futurist "passion for things under development"), wiry workers strain to bridle cart horses on the city's industrial periphery. Their bodies pitch at dramatically diagonal angles in what the artist called a "synthesis of labor, light, and movement." For all its seething energy, Boccioni's image of modern toil remains anchored to fundamentally 19th-century means and metaphors: rearing workhorses painted with the mystically tinged post-Impressionist strokes of Previati. Until a fateful encounter with Cubism in 1911, Futurism's ideological ambition outstripped its technical inventiveness.

With the exception of some trains and trams, the artists also largely avoided depicting actual machines. They did, however, draw extensively upon new technologies of reproduction, most notably Étienne-Jules Marey's chronophotographic studies. Applying multiple exposures to individual photographic plates,

3. Giacomo Balla, Street Lamp, 1910–11, oil on canvas, 68 3/4 × 45 1/4"
(174.7 × 114.7 cm), Museum of Modern Art, New York.

4. Umberto Boccioni, *The City Rises (La città che sale)*, 1910, oil on canvas, 6' 6 1/2" × 9' 10 1/2" (199.3 × 301 cm), Museum of Modern Art, New York.

Marey captured successive movements imperceptible to the naked eye. The Futurist painters write in their 1910 "Technical Manifesto": "On account of the persistency of an image upon the retina, moving objects constantly multiply themselves, change shape, succeeding one another...Thus a running horse has not four legs, but twenty." Balla's *Dynamism of a Dog on a Leash* (1912) and *Hand of the Violinist* (1912) (Figure 5) exemplify the attempt to render such optical persistence in paint. The blurred replication of the musician's hand over the instrument's neck evokes the turbulence of his playing, while also suggesting the duration of sound over successive—yet suspended—instants.

Cinematic montage anticipated Futurist imagery in a related vein. Jumps between disparate locations and time periods on the screen evinced precisely the fragmentation, simultaneity, and synthesis pursued on Futurist canvases. Already in 1911, the French critic Roger Allard sneered that the Italian painters possessed a "cinematograph in [their] bellies"; Ezra Pound remarked to James

5. Giacomo Balla, *The Hand of the Violinist (The Rhythms of the Bow)*,
1912, oil on canvas, Estorick Collection of Modern Italian Art, London.

Joyce that Futurist imagery amounted to "spliced
cinematography." Several members of the movement (including
Balla and Marinetti) embraced the association, and championed
film as a Futurist medium in its own right by 1916. Boccioni and
others strongly opposed comparisons to any form of photographic
reproduction, however. Their opposition stemmed from
photography's perceived positivist applications: the predominantly
empirical—rather than intuitive—uses to which its reproductions
were routinely put.

This sheds wider light on some of Futurism's (often
misapprehended) paradoxes and their ideological consequence.
The movement remains widely perceived as a crusade for
technological advance. For all their rhetorical worship of
machines, however, the Futurists flouted rationalist and scientific
applications of technology. "Just as our forebears took the subject
of art from the religious atmosphere that enveloped them," the
painters write in their first collective manifesto of 1910, "so we

must draw inspiration from the tangible miracles of contemporary life." Futurist artists viewed mechanization not as an expedient to progress, that is, but a prosthetic extension of almost mystical insight.

To wit, Boccioni likened Futurist painting not only to the penetrating vision of X-rays, but also to the "obscure manifestations of [psychic] mediums." Marinetti likewise conflated machinic automation with transcendental expressivity. In the same breath that his founding manifesto extols industry, it vows "to breach the mysterious doors of the Impossible." While Marinetti incorporated algebraic signs and ciphers into his experimental poetry—claiming to emulate the insentient objectivity of the motor and the propeller—he set these tropes to fundamentally lyrical ends: to "penetrate the true essence of matter more thoroughly and *without scientific methods*." "By means of *intuition*," he writes in the 1912 "Technical Manifesto of Futurist Literature," "we shall overcome the seeming irreducible divide that separates our human flesh from the metal of motors."

The Futurists, in short, rejected intellection for an embodied, irrational activism. And while they derided cultural authority, they never relinquished authorial genius as the means by which to re-enchant an increasingly soulless and secular modernity. In this sense, the Futurist preoccupation with technology belies a more profound fixation, at once atavistic and all too human: the power of myth. Whether in Nietzsche's philosophy or Georges Sorel's revolutionary political theory, myth formed not a set of antiquated stories, but a demiurgic force with which to shape a still amorphous modernity. Sorel's theory of the general strike and revolutionary violence merged Nietzsche's will to power with Bergson's theories of creative intuition, making over Marxism into an anti-parliamentary philosophy of action. The Florence-based avant-garde weekly *La voce* further influenced Futurism in this vein, counting among its numerous contributors a young Mussolini and Sorel himself.

Two of the journal's editors—the author-philosopher Giovanni Papini and painter-critic Ardengo Soffici—went on to found the more explicitly philo-Futurist *Lacerba* in 1913. Yet even their early work cast the moral and metaphysical failings of liberalism as a fundamentally *aesthetic* question. This further shaped the Futurist mission as an ideological one, precisely in its creative revolt. As Marinetti would later aver in his manifesto "Beyond Communism" (August 1920): "We will solve the social problem artistically." The Futurists championed modern life above all else. Yet they held artists to be privileged visionaries of modernity's psychic and spiritual—rather than merely materialist—dimensions.

Marinetti was the first avant-gardist to exploit mass communication in promoting this privilege. He bankrolled the pamphlets, advertisements, and publicity junkets used to publicize his movement at home and abroad, merging aesthetic insurgency with a well-oiled entrepreneurship. Italy had witnessed anti-academic tendencies similar to those in other European nations. Yet the "Scapigliati" (literally "unkempt") artists and poets of late 19th-century Milan were predictably bohemian in their nonconformism; the Futurists, in their neckties and bowler hats, instead looked quite like the bourgeoisie they aimed to scandalize (Figure 6). In the event, their movement proved as philo-capitalist as it was stridently anti-bourgeois. The 11th point of Marinetti's 1913 "Destruction of Syntax" manifesto exalts the "passion, art, idealism of Business. New financial sensibility." As much as it shaped Italian Futurism in particular, his knack for self-promotion influenced the wider trajectory of 20th-century culture. For, rather than abjure art's ineluctable truck with commerce, Futurism made of that rapport—from the earliest manifestos up through Fortunato Depero's "Manifesto of Advertising Art" (1931)—a further conceptual facet. Cultural agitation merged seamlessly with marketing savvy.

As the obverse to his polished cosmopolitanism, Marinetti vaunted a different set of origins. "The creator of Futurism," once

6. The Futurists in Paris, February 1912; from left to right, Luigi Russolo, Carlo Carrà, Filippo Tommaso Marinetti, Umberto Boccioni, and Gino Severini.

declared the critic Silvio Benco with tendentious cheek, "is an African. Whoever wants to forget it will be reminded from time to time." From the eponymous Africanism of Futurism's inaugural novel *Mafarka*, to the "African Poem" written to champion Mussolini's invasion of Abyssinia in 1936, Marinetti used his exotic upbringing as a lightning rod for Italian nationalism. In seeking to strip that nationalism of its conservatism—to invest it instead with revolutionary dynamism—he downplayed his bourgeois extraction in favor of a self-styled "primitivism."

To some degree, this echoed wider avant-garde strategies on the eve of World War I: the incitement of an enervated European culture by means of ethnographic atavism. Boccioni remarked to this end that "like the appearance of central African idols and fetishes in the ateliers of our friends in Montmartre ... we Italians need the savage in order to renew ourselves." Yet Futurism's fetish of choice was modernity. Calling themselves "primitives of a new

22

sensibility," the artists sought to make of Western contemporaneity itself something provocatively exotic.

For a while, these ambitions emerged on paper in advance of practical realization. The Futurists' first manifestos seemed to supplant the very experiments they announced. The German painter Franz Marc remarked of the Futurists to Wassily Kandinsky in 1912: "I cannot free myself from the strange contradiction that I find their ideas, at least for the most part, brilliant, though am in no doubt whatsoever as to the mediocrity of their works." This same year saw the Futurists begin redressing that mediocrity. Finally encountered firsthand in Paris, Cubist painting, collage, and sculpture lent the Futurist campaign a revolutionary style to match its rhetorical fervor.

Yet whereas Cubism remained a revolution of artistic form, Futurism aimed its insurgency at every imaginable facet of experience, seeking to shatter the boundaries between art and life itself. "If our pictures are Futurist," the artists announced in the manifesto for their 1912 Parisian debut, "it is because they are the result of absolutely Futurist conceptions, ethical, aesthetic, political, and social." Indeed, the movement's challenge to 20th-century culture lay not in any specific set of images or objects, but a more comprehensive and conceptual revolution of modern sensibility.

Chapter 3
Early Futurist theory and practice

For all of Futurism's Italianness, its beginnings—from Marinetti's founding manifesto to the group's first major exhibition—are bound up with Paris. A growing international public, in fact, served as both the foil and the fuel to the movement's nationalist drive. Despite their iconoclastic pronouncements, the Futurists never renounced the art market's imprimatur, and the French capital remained the Holy Grail of avant-garde achievement.

Marinetti secured for his painters an exhibition at Paris's Bernheim-Jeune Gallery in the winter of 1912, taking it thereafter to London's Sackville Gallery and Herwarth Walden's *Der Sturm* gallery in Berlin. All the while, Balilla Pratella's manifesto of "Futurist Music" (1911) and Valentine de Saint Point's "Manifesto of the Futurist Woman" (1912) extended the movement's concerns beyond the domain of literature and the visual arts—a momentum continued through pronouncements on theater (1913), architecture (1914), set design (1915), and dance (1917). The flurry of accompanying exhibitions, performances, and lectures—as well as an always clamorous reception in the local press—thrust Futurist activity into an ever wider spotlight.

The Bernheim-Jeune Gallery offered the most prominent possible forum in which to present Futurist achievements by 1912. On the eve of the show, however, those achievements risked seeming

embarrassingly outmoded. As the only member resident in Paris (since 1906), Gino Severini kept his peers apprised of modernism's latest innovations—most urgently, the Cubism of Pablo Picasso and Georges Braque and its swift assimilation by the advanced painters of the day. Rightly fearing their post-Impressionist style out of date, the Futurist crew traveled to Paris in October 1911 (on Marinetti's dime) to tour modern studios and salons. They spent the following three months back in Milan hastily reworking a number of paintings.

Accompanying their February 1912 exhibition of 35 works, the manifesto "The Exhibitors to the Public"—with the painter Giacomo Balla now among its signatories—differentiated Futurist aims from those of competitors.

> What we have attempted and accomplished, while attracting
> around us a large number of skillful imitators and as many
> plagiarists without talent, has placed us at the head of the European
> movement in painting by a road different from, yet, in a way,
> parallel with that followed by the Post-impressionists, Synthetists
> and Cubists of France, led by their masters, Picasso, Braque,
> [André] Derain, [Jean] Metzinger, [Henri] LeFauconnier,
> [Albert] Gleizes, [Fernand] Léger, [André] Lhote, etc....
>
> They obstinately continue to paint objects motionless, frozen, and
> all the static aspects of Nature...We, on the contrary, with points of
> view pertaining essentially to the future, seek for a style of motion, a
> thing which has never been attempted before us.

While acknowledging Cubism's challenge to academic convention, the Futurists accused its practitioners of an insidious traditionalism. Though a necessary corrective to Impressionist dispersion, Cubism's emphatic geometries arrested the image in a "masked academicism," or so Boccioni and his peers claimed. Only Futurist works evinced the mental and sensory conditions of modern existence in its unprecedented agitation: fragmented,

dynamic, simultaneous. The core artists set about parsing "plastic" solutions to these questions in practice and in theoretical texts such as Carrà's "The Painting of Sounds, Noises, and Smells" (1913), Severini's "Plastic Analogies of Dynamism" (1913), and Boccioni's more numerous manifestos.

The artists themselves cut a dashing figure in their publicity photo for the Bernheim-Jeune show (Figure 6). Their paintings, however, were dismissed as provincial by the French critic (and early champion of Cubism) Guillaume Apollinaire. The Futurists would spend the next few years refining their approach to the interpenetration of pictorial volumes—a "plastic dynamism" further detailed in the movement's so-called "Bible": Boccioni's widely disseminated *Futurist Painting Sculpture* (1914). The 1912 Paris show fired the first salvo of these efforts. At last in step with avant-garde innovation, some of the Futurists' pictures began to match their makers' peremptory affirmations.

The fractured geometry of Boccioni's *The Street Enters the House* (1911) borrows from Cubism even as it exchanges a monochrome palette for kaleidoscopic vibrancy. In and upon the body of a woman at a balcony converge the vectors of interior space and the vigorous activity of the street below. The calm of cloistered domesticity is rendered inextricable from wider forms and forces, as a leaping horse sprouts improbably from her hip and another pokes its head through the balcony grill. Though proletarian labor still anchors Boccioni's scene, his concern now lay chiefly with perceptual, pictorial, and phenomenological dimensions—with, as he put it, "the sum total of visual sensations which the person on the balcony has experienced." To recreate in paint not merely an image but experience itself: this became Boccioni's driving aim.

Carlo Carrà's *The Funeral of the Anarchist Galli* (1911) (Figure 7) commanded even more attention at the Bernheim-Jeune. The artist had attended the burial of an anarchist worker killed by police during a strike action in 1906; the funeral procession sparked

7. **Carlo Carrà,** *The Funeral of the Anarchist Galli,* **1910–1911, oil on canvas, 6' 6 1/4" × 8' 6" (198.7 × 259.1 cm), Museum of Modern Art, New York.**

further skirmishes, which Carrà sketched and later reworked in a Futurist key. At nearly three meters wide and two meters tall, his largest work updated in both subject and style Marinetti's paean to the "multicolored, polyphonic tides of revolution in the modern metropolis." Police on horseback clash with black-clad anarchists waving flags and fists around a coffin draped in red. Their collective agitation vibrates in reticulated webs across the painting's turbulent surface—Futurist "force-lines" of radiating energy, which Carrà duly revised with angular Cubist faceting.

Yet—perhaps surprisingly for a movement inimical to art's history—the painting also evokes Paolo Uccello's *Battle of San Romano* (1435–60). The mounted police in Carrà's painting echo the Renaissance panels' jousting cavalry; the thrusting flagstaffs of his anarchists recall the lances imparting linear vigor and depth upon Uccello's scene. It is less academic illusionism that Carrà

emulated than a sense of historical ambition. Still, the space opened up in the painting's foreground invites the viewer to step into its fray. More than any painting to date, *The Funeral of the Anarchist Galli* exemplified the Futurist drive to "re-enter life," reiterated in the manifesto accompanying the exhibition in plain allusion to Carrà's image:

> With the desire to intensify the aesthetic emotions by blending, so to speak, the painted canvas with the soul of the spectator, we have declared that the latter "must in future be placed in the center of the picture."
>
> He shall not be present at, but participate in the action. If we paint the phases of a riot, the crowd bustling with uplifted fists and the noisy onslaughts of cavalry are translated upon the canvas in sheaves of lines corresponding with all the conflicting forces following the general law of violence of the picture.
>
> These force-lines must encircle and involve the spectator so that he will in a manner be forced to struggle himself with the persons in the picture.

For mere pictures of violence, the Futurists substituted a violence of pictorial effects. The faithful documentation of urban modernity mattered less than plunging the viewer into its psychological dimensions.

For, the external trappings of industry and technology would never suffice to evoke their consequence for *inner* life. This underscores Futurism's avowed divergence from Cubism. The latter was said to evince an unfeelingly intellectual analysis of reality. Futurist artists concerned themselves instead with its affects and intuitions. "In order to render a vortex," Carrà avers in one manifesto, the contemporary artist "must be a vortex of sensation himself, a pictorial force and not a cold, logical intellect."

Vital in this regard was the philosophy of Henri Bergson, which motivated Boccioni's painting and theory in particular. Boccioni's

three *States of Mind* (1911) paintings cemented his assimilation of Cubist techniques and issued a declaration of competitive intent at the Bernheim-Jeune. He had completed earlier versions of the triptych in a post-impressionist vein; these he updated with an angular severity indebted to the Cubist grid. Centered upon train stations, each painting deploys line, color, and shape to evoke the moods of the travelers depicted therein. A curtain of thick lines and muted palette conjures up melancholy in *Those Who Stay* (1911) as strikingly as the hunched figures who recede into its pictorial space. The numbers stenciled on the picture plane of *The Farewells* (1911) recall Cubist collage, just as the painting's steam train recalls Claude Monet's *Gare St. Lazare*.

Boccioni's interest lay not in surface events, however, but their affective and even spiritual depth. "The principle of pictorial emotion," he writes in emulation of Bergson's *Matter and Memory,* "is in itself a state of mind." An object or body's essence, Bergson argued, may be seized by intuitive penetration: an insight that reveals not simply physical data, but inner dimensions. Boccioni pushed past both the immediacy of realism and the formalist architecture of Cubist form, seeking a present-tense "thickened" with anticipation and memory, expectancy and anxiety.

Not all the Futurists shared the same strategies or style. Severini mostly depicted popular café-concerts and their dancers: staples of the late 19th-century French painting on which he had cut his artistic teeth. His proximity to the Parisian avant-garde afforded a quicker assimilation of its developments than for his Italian-based peers. Among the early Futurists he remained the most closely aligned with Cubism in style. Across the canvases of *The Boulevard* (1910–11) and *Pan-Pan at the Monaco* (1911)—both on display at the Bernheim-Jeune—Severini imposed a lattice of flattened forms, reducing to the same planar shapes a thrusting leg or beam of light, a table top or the space beneath it. If these works risked a certain two-dimensional decorativeness, his *Dynamic Hieroglyphic of the Bal Tabarin* (1912) (Figure 8)

8. Gino Severini, *Dynamic Hieroglyphic of the Bal Tabarin*, 1912, oil on canvas with sequins, 63 5/8 × 61 1/2" (161.6 × 156.2 cm), Museum of Modern Art, New York.

ventured a more kaleidoscopic vision. A monocled bourgeois peers up the dress of a performer in the painting's bottom right corner; below him, a hat appears simultaneously visible from the side and from above, its circle curling improbably outward to intersect with the scroll of a cello. The painting's flurry of ambient forms are as fastidiously contoured as they are unmoored from figurative syntax, thrusting the viewer into a field of protrusion and recession, solidity and evanescence. Severini gives away the game of illusionism even as he mimes its methods: to purple dresses he has appended real sequins, while the word "VALSE" [waltz] sits squarely on the canvas's surface in defiance of pictorial depth.

The step to outright abstraction was a short one. Severini's *Sea=Dancer* paintings (1913) disembody corpulence into cylinders and wedges even more radically than Boccioni's *Dynamism of a Footballer* (1913), while *Expansion of Light* (1913–14) retains no referent other than what the Divisionist painter Gaetano Previati had called a "luminous vibration" of color. These contributed to a wider wave of non-objective painting by artists like Léger, Delaunay, and František Kupka, who likewise distilled strains of abstraction from Cubist forms. Balla pioneered his own version of abstraction with the *Iridescent Interpenetration* series (1912–13): meticulous geometric tessellations which evoke light shimmering across a chromatic spectrum. The paintings undertake to isolate the evanescence of light itself as a plastic value—something Balla pursued even more assiduously in numerous speed studies. Hurtling automobiles and airborne swifts provide touchstones for the even more fleeting phenomenon of speed—a force with both physical and mental ramifications for the Futurists. Like Boccioni, Balla entertained an interest in the occult sciences, and his images' undulations evoke metaphysical phenomena as much as anything empirical.

Yet Balla's crisply linear style also distinguished itself as an alternative to Boccioni's stormier brushwork—an alternative taken up by the young painters Fortunato Depero and Enrico Prampolini, whose work alongside Balla augmented the Futurist presence in Rome after Boccioni's untimely death. Dedicated to the latter and distilling his figure to a hieroglyph of solid forms, Balla's sculpture *Boccioni's Fist* (1916–17) stands out among early Futurist experiments and came to feature on the movement's official stationery. Balla's affinity for geometric solids and volumes led him to experiment with various materials in three dimensions by 1914, from abstract distillations of speed to multi-media assemblages. The Futurists had vowed to "place the spectator in the center of the picture." Yet sculpture could invade the viewer's space more immediately, concretizing dynamism rather than merely representing it. "These days I am obsessed by sculpture!

I believe I have glimpsed a complete renovation of that *mummified art*," Boccioni wrote to his friend Vico Baer just before penning the "Manifesto of Futurist Sculpture" (1912).

His *Unique Forms of Continuity in Space* (1913) (Figure 9) renders that renovation strikingly visceral. Nearly life-size and

9. Umberto Boccioni, *Unique Forms of Continuity in Space*, 1913, bronze, 47 3/4 × 35 × 15 3/4 in. (121.3 × 88.9 × 40 cm, 90.7 kg), Metropolitan Museum of Art, New York.

vaguely human, it pitches forward in a diagonal stride, furrows and protrusions rippling across its burnished surface. Arguably the movement's most recognizable icon (and featured today on the 20-cent euro coin) the figure registers movement not through successive notations, but rather—as its title insists—a streamlined continuity. Boccioni referred to the *Unique Forms* as a "true bayonet attack." He rehearsed the figure in plaster studies, gradually subsuming external armatures into the body itself. It was only decades after his death that *Unique Forms* was cast in bronze at Marinetti's behest—echoing his own exhortations to "metallize" the human face. These castings arguably travesty Boccioni's conception of the sculpture in plaster, the impermanence of which he exalted over the "traditional dignity of marble and bronze." Still, even plaster versions prompted the figure's description by the young art critic Roberto Longhi as "metallic," evincing a "dermal resistance." The barb in lieu of a face suggests the "inhuman type" championed by Marinetti in his 1911 manifesto "Multiplied Man and the Reign of the Machine." Even (or especially) in its inhumanness, Boccioni's figure is gendered male. Nietzsche's writings echo in Boccioni's efforts, as in Futurism at large. The philosopher spurred readers to "trust no thought" not born of movement and muscles, to nourish "self-overcoming" as the remedy to a "tame, mediocre, emasculated" modernity.

The redoubled materiality of sculpture—as both artwork and object—rendered it the ideal proving ground for Boccioni's theory of "physical transcendentalism." The mundane subject of his *Development of a Bottle in Space* (1912–13) redoubles its aesthetic ambition in this regard. The bottle's very fixity and familiarity— especially as a commonplace of modernist still life—underscores the sculpture's challenge to received ideas. For Boccioni, the apparent stillness of *any* object belied a flux imperceptible to the casual observer but evident to the intuitive artist. Inspired by Bergson's mystically inflected metaphysics, Boccioni avers in his "Futurist Sculpture" manifesto (April 1912) that the notion of

objects or bodies as discrete entities simply ignores their constant interpenetration with a wider environment.

> No one still believes that one object finishes off where another begins or that there is anything that surrounds us—a bottle, a car, a house, a hotel, a street—which doesn't cut into and sectionalize us with its arabesque of curves and straight lines.... The thing we are creating is only a bridge between an external plastic infinity and an internal plastic infinity; hence objects really never come to an end, but intersect each other with infinite combinations of attraction or repulsion.

His *Bottle* forms just such a "bridge." Interior and exterior no longer structure each other as opposites but as parts of a continuum. Boccioni and his peers found such continuity anticipated in the sculptures of Medardo Rosso (1858–1928), who had opened up sculptural form to the contingencies of light and time, rejecting academic idealism and its embalmed polish. Whether in bronze, plaster, or wax, Medardo's figures come continually into being out of their own materiality, blurring the boundaries between the sculpted body and its environs.

The Futurists assailed the boundaries between media with the same vigor. "There is no such thing as painting, sculpture, music, or poetry," Boccioni insisted in 1912, "there is only creation!" Though Luigi Russolo began as one of the original Futurist painters, he never shared his peers' technical facility. As a theorist, composer, and designer of experimental instruments, however, his example rippled well beyond Italy's borders. Detailed in his 1913 manifesto "The Art of Noises" and codified in the 1916 book of the same name, Russoli's experiments collapsed the distinction between music and noise. Though the actual music of the young composer Balilla Pratella retained a certain Romantic cast, his "Manifesto of Futurist Musicians" (1911) spurred Russolo's more radical innovations, wherein the simultaneity of disparate rhythms and timbres conflated acoustic "figure" and "ground."

10. Luigi Russolo and Ugo Piatti with Russolo's noise intoners (*intonarumori*) in Milan, 1913.

These effects Russolo systematized with "noise intoners" (*intonarumori*): wooden parallelepipeds with internal metal strings vibrated by external cranks, amplified in turn by cone speakers (Figure 10). The original devices are no longer extant. Yet modern reconstructions recapture the sonic range of the *rombatore* (rumbler), *sibilatore* (hisser), and the dozens of other varieties designed by the artist. To a duly scandalized public at Modena's Teatro Storchi in June 1913, Russolo debuted the *scoppiatore* (exploder), thereafter bringing a larger "orchestra" of noise intoners to Milan, London, and (after World War I) Paris. He and assistants played compositions—whether "The Meeting of Automobiles and Airplanes" (1913) or "The Awakening of a City" (1914)—according to enharmonic scores still emulated by electronic musicians today.

The modern city inspired Futurist soundscapes, sound poetry, and "plastic" visions of all sorts. Yet what of actual Futurist architecture? Considering the city's centrality to its aesthetic and ideological imperatives, the movement's lack of an architectural

program appeared increasingly glaring. The diminutive construction of Boccioni's sculpted *Bottle* related to larger theories of volumetric and tectonic fabrication, and he even penned a manifesto of Futurist architecture by 1914. This went unpublished, however, as Marinetti opted to recruit an actual draughtsman as the movement's official architect. Trained at Milan's Brera Academy and originally associated with the same city's Nuove Tendenze group, Antonio Sant'Elia developed a portfolio of drawings titled *La città nuova*, along with a manifesto of Futurist architecture duly reworked by Marinetti (Figure 11). Sant'Elia's "New City" repudiated stylistic, material, and historicist conventions for sleek structures linked by innovative transport networks (tunnels, elevators, bridges, air travel). The Futurist house, Sant'Elia insisted, would be built "like a gigantic machine." Stripped of decoration, his stepped façades, train stations, and power plants anticipated elements of the rationalism developed in the 1920s and 1930s by Le Corbusier and other leading modernist architects.

Though his career was cut short by death in 1916 and his projects remain unrealized, Sant'Elia exerted a lasting influence on 20th-century design—not merely as a visionary architect but in his proposed syntheses of modern urban form and technological function. Already during the war, Balla and Depero sought to employ Futurist ideas in a comprehensive refashioning of the built environment. Applying "constructive and architectural genius" to every imaginable format—and to still others yet to be invented—their "Futurist Reconstruction of the Universe" envisioned an integration of aesthetic imperatives with everyday living. Exhibited at Paris's 1912 Salon d'Automne, Raymond Duchamp-Villon and André Mare's *Maison Cubiste* had already proposed the application of Cubism to architecture. Yet this remained a literally superficial affair—a building façade enlivened with some decorative geometric faceting. The Futurists aimed instead to push past the world's surface to reconfigure its structuring elements, along with the mental and affective tools entailed in using them.

11. Antonio Sant'Elia, Air and train station with funicular cableways on three road levels from *La città nuova*, 1914.

This did not mean the artists were not self-conscious about the precedence of Cubism. A few key advocates in Italy hastened to flout detractors and to parry any accusations of derivativeness. Comparing Futurist imagery to Cubist counterparts, the young critic Roberto Longhi invoked the terms that the art historian Heinrich Wölfflin had famously used to contrast Renaissance artists with their Baroque successors. Like the latter, Longhi

averred, the Futurists transformed the static circle into the kinetic ellipse; their evocations of relentless motion dynamized the staid matter-of-factness of geometry.

Yet Longhi's formalist praise ignored the ideological campaign to which Futurist imagery was wholly and indissolubly bound. Any purely technical analysis would neglect the more radical upshot of the Futurist revolution: that technique itself no longer constituted the chief benchmark of aesthetic innovation. "We desperately want to re-enter into life," the Futurist artists claimed in one of their earliest manifestos. Indeed, the performance of these same texts—in public forums from Turin to Florence to more provincial cities—exemplified the attempt to transcend the limits of the page and the stage, the frame and the plinth. These rowdy Futurist *serate* (evenings) entailed the recitation of poetry and manifestos. Yet their chief aim was extemporaneous provocation and even physical altercation—events at which even police intervention proved indistinguishable from artistic performance. Italy's belated intervention into world war soon transformed these aesthetic aggressions into something more violent still.

Chapter 4
From *Words-in-Freedom*
to war

Known in European history as the "Belle Epoque," the years preceding World War I appeared to the Futurists anything but beautiful. Or rather, it was precisely the period's relatively tranquil gentility which belied—for a generation of restless Italian artists—a decadence as political as it was aesthetic. Notwithstanding Italy's still recent incorporation as a modern state, the stale pragmatism of its parliamentary democracy seemed to mirror the sclerotic pomp of its cultural patrimony. Elected numerous times since the century's turn, the prime minister Giovanni Giolitti embodied a stubbornly centrist consensus, holding at bay the mounting—and eventually intersecting—extremes of revolutionary left and right. Marked by equal parts economic progress and corruption, the liberal status quo found itself beleaguered by class unrest, nationalist agitation, and unprecedented combinations thereof.

Despite Italy's membership in the "Triple Alliance" with Germany and Austro-Hungary, the latter's control of the port city Trieste on Italy's northeastern edge further incited Giolitti's detractors. For the Futurists and others, the "Adriatic question" crystalized the larger failings of Italian statecraft. In their eyes, the nation's impotence on the world stage owed something to a woeful lack of colonies, especially compared to Western European peers. All Italy had to show from the Scramble for Africa was a tiny outpost in

Eritrea—small consolation for a disastrous defeat in the first Italo-Ethiopian war of 1895–96. With the government mired in domestic proceduralism, the Balkan crisis of 1908 left nationalists even more anxious to redress Italy's international inconsequence.

The continued dissolution of the Ottoman Empire provided further opportunities. Revolutionary Socialists, including a young Benito Mussolini, opposed the invasion of Libya. Yet even Giolitti could not pass up the prospect of a colony in North Africa. Italy declared war by September 1911. As the first in history to involve aerial bombardments by plane, along with the wireless telegraphy pioneered by Guglielmo Marconi, the Italo-Ottoman war made manifest many of the technological spectacles envisaged by Marinetti—phenomena which further spurred his pen.

Serving in Tripoli as a correspondent for the French paper *L'Intransigeant*, Marinetti seamlessly merged journalistic work with literary pursuits. Written in French and translated into Italian two years later, the poem-chronicle *The Battle of Tripoli* (1912) exalted the trenches as sites of "orchestral" adventure, of revitalizing shrapnel and shelling. "How beautiful it is to feel oneself in the rifled barrel of a monstrous machine gun, at once Futurist bullet and bull's-eye." The text already lay bare the giddy callousness of Marinetti's warmongering. Yet it was with his subsequent experiments during the First Balkan War that a theory and practice of Futurist poetics assumed its most violently exuberant form. Not only did poetry require a new syntactical violence commensurate with modernity, per Marinetti; modern violence needed a new poetics capable of evoking its particular "beauty."

Reprising his role as a war correspondent, he witnessed firsthand the defeat of Ottoman regiments by Bulgarian and Serbian forces at the Siege of Adrianople in 1912. Here Marinetti created his first *parole-in-libertà*, or words-in-freedom: verse liberated not simply from rhyme or meter, but also from syntactical logic and typographic propriety. With characteristically breathless pace, the poem

"Bombardment" describes various events: the ambush of a Bulgarian radio unit; the capture of a Turkish observation balloon; Howitzer explosions lighting up the city's periphery (Figure 12). Words now unfurled across and down the page without any regard for temporal progression or even narrative coherence.

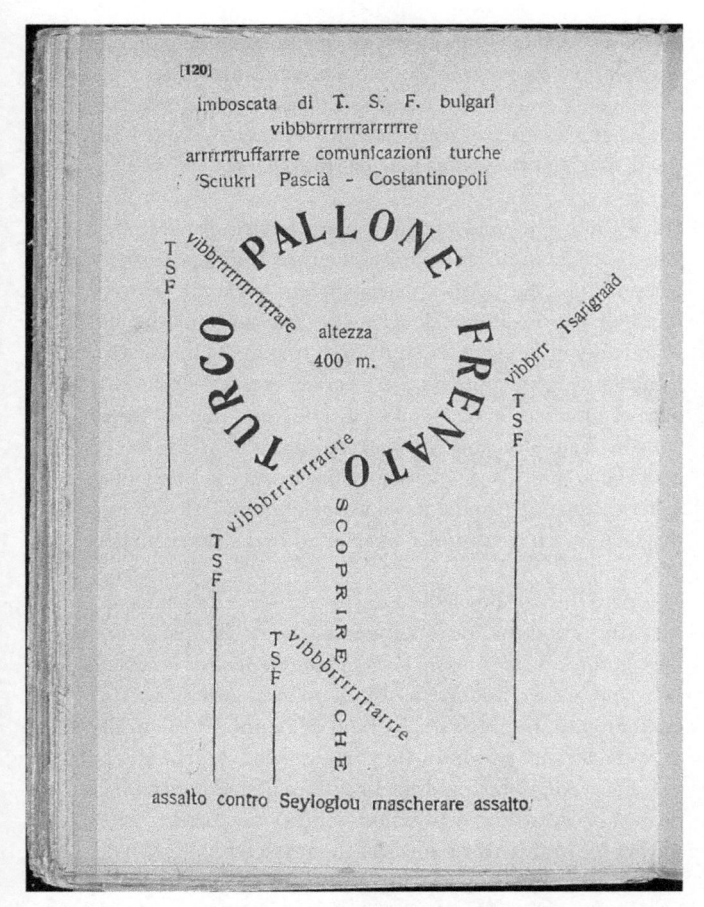

12. F. T. Marinetti, *Zang Tumb Tuuum*, Milan, Edizioni Futuriste di Poesia, 1914.

> ...2000 shrapnel to saw the air to explode white kerchiefs full of gold Boom-Boomb 2000 grenades straining to rip out with tearing shocks of dark hair ZANG-BOOM-BOOM-ZANG-BOOM-BOOOMB orchestra of the war noises to swell beneath a note of silence held in the high sky spherical balloon golden that surveys cannon-fire...

From in and among Marinetti's paratactic mixture of descriptors erupt various onomatopoetic annotations, drawn from the sound of weaponry and its physical effects. These aimed to plunge the reader into a sensorial realm as much as a cerebral one—to feel, smell, and hear the war as much as to picture it.

Other emphases (bold typeface, capital letters, disparate fonts) stress specific words and phrases while enlivening the page's visual composition. Marinetti's language oscillates among different registers: conversational, journalistic, epic, and simply sonic. But so too does its appearance shift: from traditional linear spacing to arrangements meant to be *seen* as much as read (Figure 13). One page of "Bombardment" renders the aforementioned Turkish balloon as simultaneously verbal (the words denoting its materiality) and visual (the composition of these words in a spherical shape). Around its floating signifiers flash various diagonal "vibrrrrrrrrrations" at an angle to the page's plane.

Marinetti duly acknowledged the precedent of Stéphane Mallarmé's typographic experiments. The empty spaces on the page of the latter's *Un coup de dés jamais n'abolira le hasard* (1897), however, underscored that poem's sense of quiet contemplation—precisely the kind of Symbolist solemnity and hieraticism that words-in-freedom assailed. Marinetti claimed that his typographic modifications stimulated a mimesis of physical gesture and expression—effects rendered most salient during his oral performances of the texts, with all the embodied excitability of pitch, pace, and gestural emphasis (he would later perform "Bombardment" in London, Moscow, and other cities).

13. F. T. Marinetti, *Après la Marne, Joffre visita le front en auto* (After the Marne, Joffre visited the front by car), *Words-in-freedom* (*Parole in libertà*), 1915, brochure, 29 × 23 cm, Fondazione Massimo e Sonia Cirulli, Bologna.

Crucially, Marinetti insisted with equal vehemence upon the *depersonalized* effect of words-in-freedom, vowing to "destroy the 'I' in literature." Poetry would evoke not some vague interior lyricism, but instead would channel the cold precision of machines and motors—an imperative dictated to him, he claimed in the

43

1912 "Technical Manifesto of Futurist Literature," by a plane's whirring propeller.

> Be careful not to assign human sentiments to matter, but instead to divine its different governing impulses, its forces of compression, dilation, cohesion, disintegration, its heaps of molecules massed together or its electrons whirling like turbines. There is no point in creating a drama of matter that has been humanized. It is the solidity of a steel plate which interests us as something in itself, with its incomprehensible and inhuman cohesion of molecules or electrons which can resist penetration by a howitzer. The heat of a piece of iron or wood leaves us more impassioned than the smile or tears of a woman. We want literature to render the life of a motor...

The poem "Battle Weight + Smell," for instance, uses mathematical symbols to conjoin unrelated words: "Sun = vulcan + 3000 flags precise atmosphere corrida fury surgery lamps." The introjection of statistics and integers into startling juxtapositions tempers their war-scarred horror—and whatever remained of their humanism—with a detached "numerical sensibility."

Such contrasts draw upon the effects of collage, itself a means of reconciling (objective) mass-produced materiality to (individual) artistic intervention. Even a young Antonio Gramsci (the future co-founder of Italy's Communist Party) marveled at the "decomposition of the image" in *The Battle of Adrianople* (published in the journal *Lacerba* in March 1913), comparing its effects to contemporary paintings by Picasso and Ardengo Soffici. Indeed, Marinetti's experiments followed closely on the heels of the Futurist painters' trip to Paris in the fall of 1911, where a firsthand encounter with Cubism overhauled the Futurist approach to pictorial simultaneity.

In the wake of the Balkan conflicts, avant-garde assaults on pictorial space resonated with wider anxieties about geography and borders. With the assassination of Archduke Franz Ferdinand

on June 28, 1914 the prospect of continental war became reality. Italy's declaration of neutrality incited immediate tirades from the pages of the journals *La Voce* and *Lacerba*. For the Futurists, the war amounted not simply—or even chiefly—to a military affair. It represented a cultural crossroads. The right path would lead Italy away from the imperial archaisms of the Central Powers. "Will the war give us what many of our generations have expected from a revolution?" queried the writer and Futurist fellow traveler Giuseppe Prezzolini. "Faced with the totality of the event that is being completed," he answered himself, "the spirit is calm and we cannot have doubts about tomorrow." The critic and Florentine Futurist Giovanni Papini proclaimed *Lacerba*'s "love of war" and his hope for a "cleansing of the earth … [in] a warm bath of black blood."

Interventionism even briefly united Papini and Soffici's Futurist cadre to the Milanese group around Marinetti, whose work now appeared regularly in the Florentine journal. The promise of a new conflagration lent fresh relevance to his words-in-freedom, which he published in book form as *Zang Tumb Tuuum: Adrianople October 1912* (1914). The volume slotted poems between the expository "Technical Manifesto of Futurist Literature" (1912) and "Destruction of Syntax" (1913). Marinetti would never let pedantry eclipse performativity, however. Like the poems of fellow free-wordists Francesco Cangiullo, Angelo Rognoni, Paolo Buzzi, and Luciano Folgore, his verse was intended to be read aloud.

The very first Futurist *serata* had been held in the Adriatic city of Trieste in 1910, demonstrating the movement's long-standing irredentism. The war's outbreak exacerbated anti-Austrian sentiment. It also rendered Futurist performance virtually indistinguishable from activism. The Futurists interrupted operas in Milan to tear apart the Austrian flag. Yet they also took their show on the road in more organized forms, performing in various cities under the avowed premise that it was "only through theater

that we can instill a warlike spirit in Italians." The ensuing drama most often spilled beyond the stage.

In his manifesto "The Futurist Political Movement" (1915), Marinetti boasted of having personally beaten up various opponents of the war. He also stylized that violence in and as the very act of reading. Certain pages of Marinetti's volume *Les Mots en liberté futuristes* (1919) fold outward, forcing the reader's corporeal engagement with the poem's material support. The impulse to physicalize ideology extended from the body to its vestments. Thus Marinetti hastily rewrote Giacomo Balla's "Futurist Men's Clothing" manifesto as "The Antineutral Suit," prescribing sartorial modifications (asymmetry, aggressivity, volatility) as the remedy to pacifism and passivity. Any dedicated Futurist could now wear the war's cause—and Italy's flag—on his actual sleeve.

This is not to say that the core artists hung up their brushes. Before Italy's entry into the conflict, Marinetti urged them to "live the war pictorially," to lend it "plastic expression." Severini took that task to the letter with oil canvases like *Plastic Synthesis of the* Idea *of War* (1915) and *Visual Synthesis of the* Idea *of War* (1914), setting fragments of machinery and field cannons against the diagonal thrust of the French tricolor—the emblem of Italy's "Latin brothers" across the Alps. It is instead the red, white, and green of the Italian flag which dominate Balla's series of paintings, including *Patriotic Demonstration* (1915) and *War Traps* (1915). These works push tussling forms to the edge of abstraction, falling expressly short of figurative sense in their attempt to synthesize raw nationalist zeal.

By contrast, Picasso and Braque's collage experiments spurred Boccioni's *Charge of the Lancers* (January 1915) and Carrà's *Pursuit* (late 1914), both of which incorporate news clippings— some about the war itself—into their visual fields and individual figures. Emblazoned with a small Italian flag, the horse in Carrà's

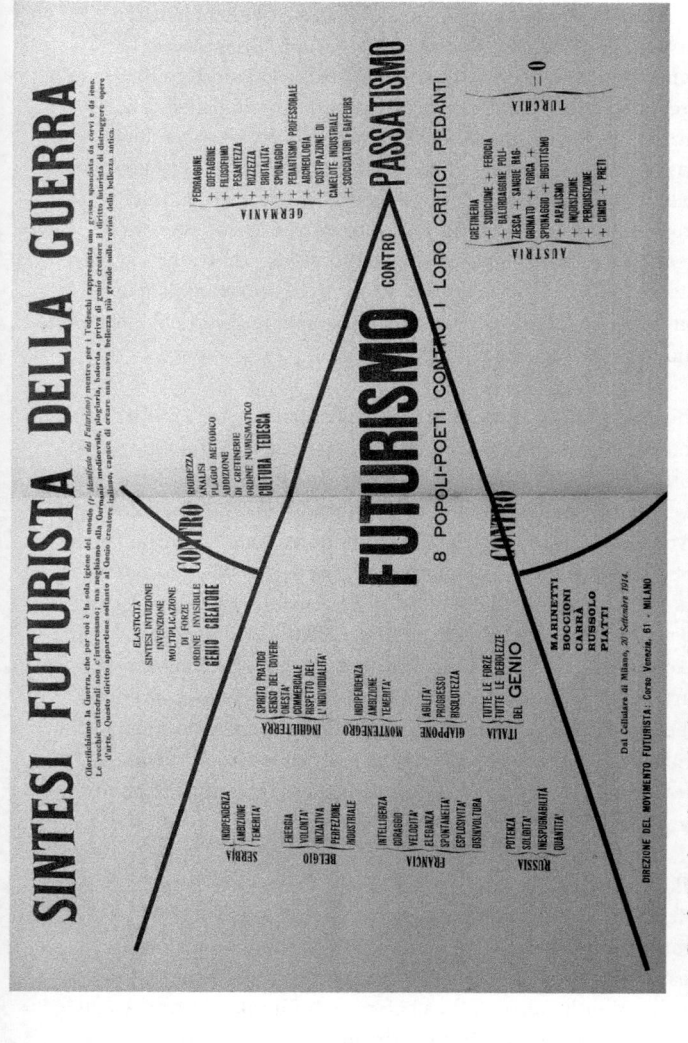

14. Carrà, Marinetti, Boccioni, Russolo, Piatti, *Futurist Synthesis of War*, central page of the manifesto leaflet, 1914, private collection.

work charges toward the name "JOFFRE" (Commander-in-Chief of French forces); in its wake hang the letters "UUUU," evoking—like Marinetti's onomatopoeia—the aural atmosphere of battle. Striking in its visual economy is the *Futurist Synthesis of War*, signed by Carrà, Marinetti, Boccioni, Russolo, and Ugo Piatti and circulated as a leaflet in September 1914. Re-published (like *Pursuit*) in Carrà's book *War Painting*, the diagram renders Austro-German culture a "passéist" rotundity, punctured by the collective wedge of the Entente powers (Figure 14). At once proclamation and illustration, it epitomizes Carrà's theory of geometric forms as bearing specific emotive, exhortatory, and even ideological effects. If diagonals epitomized the dynamism of kinetic penetration, for instance, horizontal and vertical lines were said to evoke an insipid "neutrality."

The latter find no quarter in one of Futurism's most emblematic images, Carrà's *Interventionist Demonstration (Patriotic Festival)* (1914) (Figure 15). Exemplary of what the Futurists called a "free-word panel," the collage-painting sets myriad fragments into a vortex of oblique angles. Though outsized in its importance, the actual work is quite tiny, measuring just 38.5 × 30 centimeters. Its energy far outstrips these physical dimensions, however. A swirl of layered shards generates a geometric abstraction mesmerizing in its own right, while the heterogeneous letters enlivening the work's surface (both handwritten and printed) compel closer attention. These include names, numbers, sheet music, advertisements, and, crucially, two Italian *tricolori*. The painted letters *Evvivaaaaa l'esercito…Eevviiivaaa il Re* ["Loooong live the army…Looonnng live the King"] echo that national zeal.

Like the words "[A]ustria Ung[ar]ia [Austro-Hungary]" at lower left, the placement of an irredentist banner at lower right would seem to confirm the "interventionist" title under which the work has circulated since the 1940s. However, Carrà created it prior to the war's outbreak, and thus before calls for intervention would have emerged in Italy. It thus stirs up nationalist and irredentist

15. **Carlo Carrà, *Interventionist Demonstration (Patriotic Holiday – Free Word Painting)*, 1914, tempera, pen, mica powder, and collage on cardboard, 38.5 × 30 cm (Mattioli Collection, on long-term loan to Peggy Guggenheim Collection, Venice).**

sentiment without any specific bellical reference. The collage's reproduction in *Lacerba* on August 1, 1914—the same day Germany declared war on Russia—nevertheless decisively altered its reception. It now served as a touchstone of the Futurist

intervention campaign, waged, in part, from the pages of the very same journal.

It is from *Lacerba* itself that Carrà cut most of his clippings, underscoring Futurism's intermedial (and frequently self-referential) penchants. The periodical's name in the upper left portion of the collage flanks the words *Zang Tumb Tuum*—the sonic clamor of which is echoed by excerpts from other free-word poems like Marinetti's "Dunes" (1914), Boccioni's "Man + Valley + Mountain" (1915), and Soffici's "Stroll" (1915). These range from onomatopoetic sounds ("traaak tatatraak," "trrrrrrr") to stray verbal signifiers ("echi echi echi" [echoes echoes echoes], "croc" [fang]). Like snippets of advertisements for Odol mouthwash and heartburn pills, several words alert us to an unmistakably urban locale: "pedoni" (pedestrians), "strada" (street), "folle" (crowds), and "piazza." The piazza has long formed the space of both celebration and demonstration in Italy (in contemporary parlance, "piazza" remains interchangeable with a general sense of publicness). In place of architecture or individuals in Carrà's collage, we see—and hear—exclamations which evoke a tumultuous city space.

These verbal cut-outs also constitute small *forms*, at once centrifugally dispersive and centripetally ordered. The large diagonal cut-out set against the central spiral suggests the propeller of a plane, recalling Marinetti's theories conflating linguistic function with technological propulsion: "the infinitive is round like a wheel, and like a wheel it is adaptable to all the cars of the analogical train, so constituting the very speed of style."

Just as relevant here are the synaesthetic theories of Carrà's own recent manifesto, "The Painting of Sounds, Noises, and Smells" (1913). If his *Funeral of the Anarchist Galli* (Figure 7) epitomized the early Futurist desire to put the spectator in the center of the picture, *Interventionist Demonstration (Patriotic Festival)* updated that endeavor with a sensorial turbulence, at once more stylized and less "graceful." Marinetti's fragmentation of

traditional syntax sought to make the elements of language palpable to the eye and body—an aim echoed in Carrà's prismatic shattering of perspectival space.

The work's interventionist cachet became matched by actual demonstrations in real time and space. During one of these activist sorties, Marinetti and others were arrested in Milan in 1915 alongside Mussolini—himself recently ejected from the Socialist Party for espousing a pro-war stance. The group's street battles against police and pacifists formed a kind of rehearsal for military combat. With Italy's entry into the war on May 23, 1915 this Futurist ideal was made actual. Marinetti, Boccioni, Russolo, and Mario Sironi all joined the Lombard Volunteer Cyclist Battalion. Futurist service at the front and rearguard meant a diminution of exhibitions, *serate*, and other performances. The war itself became the totalizing spectacle that the movement had sought since forming.

"Let's break out of wisdom," reads Marinetti's founding manifesto, "as if out of a horrible shell." Early Futurist experiments duly ruptured the shell of the most familiar strictures: the laws of syntax, the fixity of sculptural form, the planar propriety of the canvas. The war rendered such eruptions real—a violence which, for Marinetti, remained interchangeable with assaults upon *aesthetic* forms and formats.

> Futurist poets, painters, sculptors, and musicians of Italy! Leave aside your poems, paintbrushes, chisels, and orchestras for as long as the war lasts. The red vacations of genius have begun! We can admire nothing, today, except the formidable symphonies of shrapnel and the mad sculptures that our inspired artillery will pour down on the enemy masses.

Not even the violence to his person tempered this crusade. While convalescing from a grenade wound in 1917 Marinetti set about composing the "Manifesto of Futurist Dance," proposing performances of a Shrapnel Dance and Machine Gun Dance.

Italy's "mutilated victory"—as the meager territorial rewards accorded by the Triple Entente became known in nationalist circles—hardly ushered in the peace expected of national triumph.

The next several years found the country pushed to the brink of civil war in the so-called Red Biennium of 1919-20, with industrial actions by left-wing revolutionaries met with bloody repression by Fascist Blackshirt militias. The historian Christopher Duggan writes poignantly of this period: "herein lay the political tragedy of war. Far from healing the rifts that had so threatened the stability of liberal Italy before 1914, the experience of 1915 to 1918 served to fragment the nation more than ever."

The Futurists had not been alone in appealing for intervention. Intellectuals of various ideological stripes—including a large swathe of Italy's nationalist and monarchist right—had all clamored for war, seeing it as a corrective to the inadequacies of Giolitti's liberalism. Where the Futurists proved original was their yoking of strident nationalism and irredentism to anti-conservative politics—a "revolutionary nationalism" as Marinetti would later deem it in the "Manifesto of the Italian Futurist Party" (February 11, 1918). Uniting former socialists, anarcho-syndicalists, and the broader anti-pacifist left, Futurism reconciled revolutionary individualism to a collective will to anti-parliamentary power. The anarchism of Carrà, like the early socialist sympathies of Boccioni and Sant'Elia, gave way to a new ideological constellation anchored by the gravity of nationalism.

The death of the latter two men in 1916—Boccioni killed during a cavalry drill on August 17, Sant'Elia felled by a bullet on October 10—left the group temporarily reeling, deprived of its chief theorist and leading architect. Of 5 million Italian men conscripted in the war, over 600,000 perished, including 11 other Futurists.

Before the full realization of its horrors—millions dead and disfigured, landscapes ravaged, unprecedented civilian

casualties—the Great War had augured for many other European modernists a similarly salutary "vitalism." Inspired by the painter Fernand Léger's service as a sapper in the trenches at Verdun, his *Card Party* (1917) depicts fellow French soldiers as riveted automata indistinguishable from the machinery they wield ("utterly dazzled by the breech of a 75 millimetre gun," Léger marveled at the time, "total revolution, as man and as painter"). Mounted atop an actual industrial drill, the sculpted cyborg of Jacob Epstein's *Rock Drill* (1913–16) bears a carved homunculus in its exposed torso, recalling the all-male reproductive fantasy of Marinetti's *Mafarka the Futurist*. Though begun before the war's outbreak, Epstein's disturbing figure embodied the English Vorticist conception of the war as "a great remedy...the vortex of will, of decision."

The seemingly senseless deaths of so many individuals—including the sculptor Henri Gaudier-Brzeska, who penned these lines about "remedy" before himself falling in the trenches—tempered the belligerence of many avant-gardists. Epstein, for one, would modify his *Rock Drill* out of horror at the "Frankenstein's monster we have made ourselves into." "The War has exhausted interest for the moment in booming and banging," declared the Vorticist ringleader Wyndham Lewis, who predicted that its conclusion would see the end of Marinetti's appeal.

No such end arrived. The Futurists championed Italy's victory not as a conclusion to the nationalist cause but a prelude to its fuller realization. A predictable outpouring of patriotic fervor greeted the armistice signed between Italy and Austria-Hungary on November 4, 1918. "BUT THAT IS NOT ENOUGH!" screamed the Futurist poet Mario Carli to a crowd in front of Rome's Altar of the Fatherland that same day. With a contingent of *arditi*, Futurists, and other irredentist crusaders, Gabriele D'Annunzio occupied the "unredeemed" Adriatic city of Fiume (Rijeka) in September 1919, setting up a military government which threatened to steal the cultural thunder of Marinetti and

Mussolini alike. The latter wasted no time in founding his own political movement.

Before its conservative turn in late 1919 temporarily alienated Marinetti, the early Fascist Party found in Futurism numerous mutual enthusiasts. It also found a ready-made rhetoric of youth, virility, and sense of insurgency. Consolidated from movement to regime by 1922, Mussolini's government would continue to draw—however inconsistently and superficially—upon Futurist ideals, even as it increasingly subordinated Marinetti's aims to more reactionary stances. For its part, Futurism claimed full credit for Fascism's rise. It now faced a mounting post-war "return to order," however—a conservative retrenchment in both politics and culture, in Italy and abroad, which threatened to render its destructive ethos obsolete.

Some Futurists had begun revising their styles even before the guns went quiet. After the group's infamous injunction against "passéist" subjects—and just months after his own pictorial glorifications of the war's violence—Gino Severini notably depicted his wife Jeanne suckling their newborn child in a painting titled *Maternity* (1916), for instance. Already with their "Futurist Reconstruction of the Universe" manifesto (1915), Balla and Fortunato Depero had adumbrated strategies by which to transform the war's "polyphonic" chaos into a constructive and productive creativity. Balla's tireless activity bolstered the Futurist presence in Rome, which grew in prominence and consequence following Boccioni's untimely death, Carrà's defection to other projects, and Severini's neoclassical turn in Paris. Marinetti would later recall Balla's studio as the "laboratory" of Futurism, rejoined by the multifaceted practices of Anton Giulio Bragaglia and Enrico Prampolini in the same city. Marinetti himself notably moved to Rome in 1918, deeming it "the capital of the new Italy...the power plant of world Futurism."

With the consolidation of the Fascist revolution into dictatorship by 1926, Italy's capital proved less a modernist power plant than the seat of ready-made Roman identity. The widespread reprisal of ancient iconography increasingly marginalized the relevance of Futurist agitation to Fascism's self-image. Even still, Marinetti managed not only to recruit a whole new slate of artists from all over the country, but to reconcile virulent nationalism with renewed international activity in an ever expanding range of media.

Chapter 5
Futurist totality and intermediality

In its quest to modernize Italian culture, Futurism did not merely alter representational strategies. It shattered entrenched aesthetic classifications: fine and applied, visual and aural, pictorial and performative, "high" and "low." The introduction of extraneous elements into Futurist painting and sculpture—or of noise into music, or radio dispatches into poetry—reflected a wider impetus to eliminate boundaries between media.

Futurism thus defied what the American art critic Clement Greenberg would later call "medium specificity": the notion that artistic media bear formal and material characteristics proper to their respective formats, which they dare not depart from nor share with any other. Aesthetic experiment would remain separate from life—and hence from the politics attendant upon everyday existence.

Futurism confounds this paradigm of modernist development. For rather than refine media it sought to hybridize them. Instead of stripping aesthetics of ideology it merged them more aggressively. Rather than abstract art from life, it sought to make over the world itself in Futurism's exponential image.

"There is no reason why every activity must be confined to one or other of those ridiculous limitations we call music, literature,

painting, etc." With the manifesto "Weights, Measures, and the Prices of Artistic Genius" (1914), the writers Bruno Corra and Emilio Settimelli joined their Futurist peers in assailing "Art with a capital A." The movement's most gifted artist and theorist Umberto Boccioni had already denounced "the artificial distinctions between painting, sculpture, music, literature, philosophy, poetry." Boccioni's attempts to eradicate such divisions were cut short by the Great War—itself, disturbingly enough, a laboratory of intermedial experimentation for the Futurists. The movement's architect Antonio Sant'Elia lost his life in the same war, the end of which saw other core members peel away.

Yet a few key colleagues—and a growing roster of recruits— carried on Futurist efforts into the next decades, expanding its already unprecedented multiplicity in still further directions. Indeed, for all of Futurism's vows to destroy and deconstruct, its adherents waged a parallel campaign: to integrate the most disparate disciplines into a totalizing phenomenon. Such integrations aimed to be more than merely decorative; they aimed to transform the very habits they facilitated. The gamut of utopian avant-garde projects of the early 20th century—from the Bauhaus in Germany to Constructivism in Russia, De Stijl in Holland to *Esprit Nouveau* in France—owe something of their origins to this Futurist impetus.

Marinetti's inaugural promise to "break through the insuperable barriers" of aesthetic convention heralded the explosion of broader genres. Narrative and declarative, his "Founding and Manifesto of Futurism" defied literary categorization in its own right, while the same year's *Mafarka the Futurist* (1909) scrambled the coordinates of theory and practice, prose and proclamation. The novel declares itself "polyphonic...at once a lyric poem, an epic, an adventure novel, and a play." Its titular protagonist, furthermore, is not merely a marauding sovereign and military commander, but an artist who sculpts a winged "son" from heterogeneous materials. A highly publicized trial for obscenity

merged the book's fictions with Marinetti's prowess for marketing, just as the group's rowdy *serate* would blur the lines between art and activism, particularly on the eve of war. Italy's entry into World War I would see many of *Mafarka*'s martial and aerial fantasies—along with the wider Futurist campaign to merge art and life—made brutally real. It is no coincidence that Marinetti deemed the war itself "the finest Futurist poem."

That hyperbole raised as many questions as it answered, however. Could avant-garde experimentation ever match the intensity of modern combat? Could the prose of Italy's civic life compete with the war's sensorial intensity and sheer spectacle—that is, with its all-encompassing Futurist "poetry"?

One influential manifesto written during the conflict aimed both to assimilate its cruel "polyphony" and to supersede its effects. Giacomo Balla and Fortunato Depero's "The Futurist Reconstruction of the Universe" (1915) (Figure 16) set forth a range of objects and concepts to rival what they called "the current

16. Giacomo Balla and Fortunato Depero, "Futurist Reconstruction of the Universe," 1915.

marvelous but small human conflagration" raging across Europe. Balla and Depero pledged to inject Futurist sensibility into every imaginable format and to invent others as yet unimagined. Promising transformable clothing and "phono-moto-plastic advertising," their text also incorporated six photographs of multimedia works to date: Balla's cardboard polyhedron wound with taut string, for example, and Depero's colored motorized contraption wrought from fabric, tubes, and pulleys. These striking *complessi plastici* (plastic complexes) illustrated the manifesto's "universal" ambition: to remake existence according to Futurist principles. "We shall find abstract equivalents for all the forms and elements of the universe, then combine them together according to the whims of our inspiration in order to create plastic complexes that we will put into motion."

What the artists deemed a "complete fusion" of "universal vibrations" remained enticingly unspecified. Yet it was in part the abstractness of their manifesto's utopian proposals which rendered it so compelling. It ventured not simply material innovations, but a conceptual—even metaphysical—approach to totality through modern means.

The Futurists aimed to supplant antiquated "craft" traditions with modern materials and strategies. Even still, the practice of applied arts (visible to a lesser degree in Italy's own "Liberty" style, an offshoot of Secessionism and Art Nouveau) applied aesthetic principles to everyday objects otherwise ignored by the "fine" arts. Having been commissioned to design a wealthy family's apartment in Düsseldorf in 1912, Balla witnessed firsthand the innovations of Mitteleuropean Secessionism. It was this sense of comprehensiveness that Balla and Depero emulated and transformed. Their solid, volumetric style, furthermore, lent itself to more tectonic applications. Alongside the "decomposition," "deconstruction," "dispersion," and even "dismembering" championed in early Futurist rhetoric, Balla and Depero's

constructive ethos emerged as an alternative and, gradually, a model for numerous interwar experiments.

Several Futurist texts had adumbrated related ideas, whether Bruno Corra's "Chromatic Music" (1912), Carrà's "The Painting of Sounds, Noises, and Smells" (1913), Gino Severini's "Plastic Analogies of Dynamism" (1913), or Enrico Prampolini's "Atmosphere-Structure" (1914–15). Severini, for instance, announced his intention to "enclose the universe in the work of art." After affixing real sequins to depictions of women's dresses (Figure 8), he even briefly tried his hand at a small kinetic experiment: a painted dancer whose three-dimensional legs could actually twirl. However fleetingly, such a work sets into relief the Futurist penchant for hybridized media.

The disparate components of Prampolini's *Béguinage* (1914) inaugurated his own decades-long dedication to "polymaterial" experiments, from early theories of mobile sculpture, to electromechanical set design, to multi-media murals incorporating photography in the 1930s. Carrà proposed to overhaul painting into a "polyphonic architectural whole": a sensory realm rather than a set of mere optical effects. He made these synaesthetic theories material with the (now lost) assemblage *Noises of a Night Café* (1914). Inscribed with words evoking the nocturnal buzz of some urban café, the work's planes burst their frame (and pictorial illusion) to invade the viewer's space in three dimensions. Such a work shatters the stillness of still life. Yet it also disavows any separation between the aesthetic object and its surroundings.

What Boccioni called the "sculpture of environment" aimed to incorporate a wider architectural context into and alongside the aesthetic object. His "Futurist Sculpture" manifesto encouraged artists to

> reject the idea that one material must be used exclusively in the construction of a sculptural whole. Insist that even twenty different

types of material can be used in a single work of art in order to achieve its plastic feeling. To mention a few examples: glass, wood, cardboard, iron, cement, hair, leather, cloth, mirrors, electric lights, and so on.

"Let's open up the figure and let it enclose the environment," Boccioni demanded. Into the gangly *Fusion of a Head and Window* (1912) he duly incorporated a genuine window mullion, glass eye, and braid of real hair. Exhibited alongside the *Development of a Bottle in Space* and others in Paris in 1913, its amalgamation resonated in Picasso's *Glass of Absinthe* (1914). The Spaniard famously inserted a real spoon atop this bronze simulacrum, the coiled form of which responds to Boccioni's spiraling bottle (as would Vladimir Tatlin's giant *Monument to the Third International* (1919–20) several years later).

To be sure, Cubist collage had spurred the Futurist use of heterodox materials to begin with. Boccioni's *Dynamism of a Speeding Horse + Houses* (1914–15) added the further dimension of duration, confusing the animal's anatomy with the landscape it traverses. The sculpture's fusions (of figure and ground, time and space) extend to its materials of painted paper, wood, cardboard, copper, and iron coated with tin or zinc. Balla and Depero duly acknowledged Boccioni's precedent in this regard. While praising the accomplishments of "pictorial Futurism," they vowed to transcend even more radically the "flat plane of the canvas" with ever more unlikely ingredients:

> Metal wires, strings of cotton, wool, silk, all of every possible thickness and color. Colored glass, tissue papers, celluloids, metal screens, transparencies of every sort, colored ones too, fabrics, mirrors, metallic foils, colored tin-foil, and everything gaudy or garish. Mechanical, electrical, musical, noise-ist devices; chemically luminous liquids with variable colors; springs; levers; pipes, etc.

If Futurist painting might "put the spectator in the center" of its imagery, then why could its three-dimensional objects not open up to comprise the wider world?

One of Balla's pupils in Rome, the Czech-born Růžena Zátková, created a series of media panels titled *Pitture luminose* (Luminous Paintings) (or *Quadri-sensazioni* [Paintings-Sensations]) (1919–20) (Figure 17), using collaged, abstract, and even kinetic elements to evoke phenomena like water, fog, and snow. Exemplified in his own mixed-media panels, Marinetti's theory of "Tactilism" redirected aesthetic attention from the eyes to the hand, and responded obliquely to Zátková's strikingly variegated panels. While Marinetti proclaimed the divergence of this "Art of Touch" from other contemporary avant-garde experiments, it plainly took some cues from the Cubist and Futurist incorporation of incongruous objects.

The insertion of everyday materiality into the province of art did not sit well with every Futurist or fellow traveler. Invoking both Boccioni and Picasso's work as cautionary examples, the critic Giovanni Papini decried the extent to which artists seemed to sacrifice the lyrical interpretation of reality for crude fragments of reality itself. Photography had sustained similar attacks since the 19th century: namely that it merely replicated the world instead of interpreting it. Despite the Futurist zeal for new media—and despite its painters' occasional dismissal as mere imitators of cinematic effects—the movement's rapport with photography and film proved fitful and often strained. Balla's motion and speed studies drew extensively upon Étienne-Jules Marey's chronophotographic plates, seeking to render the indivisible turbulence of motion rather than parse its components into separate images.

Joining the movement in 1911 and authoring a tract titled "Photodynamism," Anton Giulio Bragaglia sought to make of photography a Futurist medium unto itself. Influenced (like

17. Růžena Zátková, *Water Running Under Ice and Snow*, mixed media on pasteboard, with moveable parts, 19 ¼ × 15 3/8 in. (49 × 39 cm), *c.*1919–20. Milan: Private Collection.

Boccioni) by Bergson's philosophy of *élan vitale*, Bragaglia endeavored to capture the flux of physical movement while visually synthesizing both its duration and mental effects (Figure 18). Nowithstanding Bragaglia's attempt to distance his imagery from mere photography (as well as the occultist affinities informing

18. Anton Giulio Bragaglia, *Change of Position*, 1911, Gelatin silver print.

that attempt), Boccioni dismissed Bragaglia's efforts as mechanically positivist, schematic, and hence un-Futurist. Though Bragaglia was expelled from the group's ranks, artists like Marisa Mori and Wanda Wulz continued experimenting with photography into the 1930s, when Marinetti and Tato (Guglielmo Sansoni) attempted—with limited success—to relaunch it as a Futurist medium.

Bragaglia subsequently channeled some of his energy into the cinema—another intermittent nexus of Futurist "polyexpressivity." Early European film theorists had long since argued that the medium integrated the other arts—photography, literature, theater, music, etc.—into a single phenomenon. That synthesis lent itself to Futurist theories of totality. Not surprisingly, Balla and Depero's prescriptions for artistic dynamism include "cinematographic" motion (and Balla himself subsequently joined Marinetti, Corra, Settimelli, and others in signing the 1916

"Manifesto of Futurist Cinema"). Futurist film sought not to document modernity but to transform and expand its dimensions—dimensions which would now comprise "painting, architecture, sculpture, words-in-freedom, music of colors, lines, and forms, a clash of objects and realities." The seemingly magical jumps in time and space effected by montage recommended the cinema as one further means to "decompose and recompose the universe." It remained, in other words, a fundamentally *expressive* medium. Only one of its examples remains extant, however: the silent film *Thaïs* (1917), directed by Bragaglia with backdrops by Prampolini.

Tellingly, Prampolini's geometric backdrops proved more striking than the film's love story. Both he and Bragaglia increasingly dedicated themselves to the expanding possibilities of set design. In fact, notwithstanding the consummate modernity of cinema, it was the theater—and performance broadly conceived—that galvanized Futurist intermedial work well into the 1920s and 1930s. Along with a prominent publication (*Cronache d'attualità*) and exhibition space (the Casa d'Arte Bragaglia [1918–30]), Bragaglia's Teatro degli independenti (1922–31) staged work by Futurist artists as well as Berthold Brecht and August Strindberg—productions facilitated by Bragaglia's expertise in scenography and Futurist "scenoplastics."

Other key Futurists likewise approached the theater as a laboratory for formal research. Balla and Depero considered set design an extension of the abstract and kinetic forms, illumination, and sounds developed in their sculptural "plastic complexes." The Russian impresario Serge Diaghilev commissioned both artists to create sets for the Ballets Russes in Rome in the mid-1910s. Colored geometric solids flashed like fireworks to the music in Balla's designs for Igor Stravinski's *Feu d'artifice* (1917), eliminating actors and anticipating a good deal of theatrical experimentation across Europe. Though the elaborate sets and costumes that Depero designed for Diaghilev's

19. **Fortunato Depero's set design for *Le Chant du rossignol by Serge Diaghilev*, 1916–1917, mixed media, various dimensions.**

Le Chant du rossignol (1916–17) (Figure 19) remained unused, his *balli plastici* integrated sculpture and costume design, *mises-en-scène*, and architecture in versatile marionette theaters. Prampolini also conceived of set design as a means to obviate the all too human presence of actors. The mobile autonomy of his sets rendered them their own spectacle. Beginning with early theories of "Futurist Scenography" (1915), Prampolini's work tended toward that which Wassily Kandinsky would call "the synthetic work of art," consummated on the modern stage. Prampolini's ideas influenced a swathe of the European avant-garde from Paris to Poland—an eastern reach which defied, at least in aesthetic terms, Italy's political retreat into Fascist reaction as the 1920s progressed.

The relationship of Futurist totality to Fascist totalitarianism is complex and deeply fraught. Futurism helped incite the Fascist cult of youth, virility, and nationalism, underscoring the consequence of physical performance and spectacle to political ends. To wit, Marinetti's claim in "Beyond Communism" (1920) that the Futurists excelled in preparing

> citizens with an assiduous propaganda of intellectual freedom, sport, art, heroism, and Futurist originality ... We must increase human capacity to live the ideal life of lines, forms, colors, rhythms, sounds, and noises combined by genius.... While the last religions are in their death throes, Art should be the ideal nutriment ... that will console and reanimate the most restless races.

At the same time, Futurism resisted the merely teleological application of art, and rejected the Roman antiquity that increasingly formed its vehicle under Fascism. The composer and theorist Franco Casavola even argued (however unconvincingly) that the improvisational "openness" of jazz rendered it the realization of Futurist ideas.

Already in 1913, Marinetti avowed in his manifesto "The Variety Theater" that cigar smoke wafting onto the stage from the audience blurred the boundaries between public and performance. That blurring speaks to the particular, irreducible nature of Futurist ambition. The same manifesto vowed to destroy "every trace of logic," just as experiments by Balla and others anticipated Dadaist mischief far more than any authoritarian imperatives. "Balla marries a chair, and a stool is born," read one sequence in the (now lost) film *Vita Futurista* (1916). To be sure, the movement gradually shed much of its counter-cultural irreverence. With Fascism's consolidation as a regime, Futurism necessarily tempered its more progressive and revolutionary elements. Yet Futurism's relationship to Fascism's increasingly conservative culture proved more fraught than is often conceded.

Its ideological accommodations, moreover, often proved as philo-capitalist and philo-commodity as they were pro-Fascist.

"A typewriter," Balla announced in 1918, "is *more architectural* than all those building projects which win prizes at academies." His brief but seminal partnership with Depero helped extend and expand Futurism's course. The "Futurist Reconstruction of the Universe" not only inspired avant-garde experimentation between the wars, but—even more crucially—offered a paradigm for Futurist theories of totality in their own right. Beginning in the late 1960s, scholars used the manifesto as a lens through which to reconsider Futurism beyond its "painting-centric," "Boccioni-centric," and even "Marinetti-centric" iterations. These studies shed light on the "Futurist Reconstruction of the Universe" as a phenomenon that both recapitulated and hyperbolized Futurism's multifaceted ambition.

Such ambition fed into the "total environments" which amalgamated all aspects of Futurist production: like Prampolini's "House of Italian Art" and Depero's "Casa d'Arte Futurista" after it, the "Casa Balla" in Rome came in the 1920s and 1930s to form a locus of interdisciplinary production as well as a spectacle in its own right. At once a travesty *and* a consummation of Futurism's early experiments, these spaces transferred the transcendent energy of the street into the fold of the home. Such enterprises anticipated what today we call design. For, as much as it signifies a practical application, design entails a certain formal promiscuity and categorical fluidity. It means not simply the multipurpose utility of the iPhone, for example, but the applications by which its consumers/users organize their world (and are, in turn, organized by larger social and economic systems). Marking a shift in the prominence of Italian design after World War I, for instance, Ettore Sottsass's popular (and portable) *Valentine* typewriter for Olivetti (*c*.1969) derived in part from Balla's insistence upon the apparatus as piece of "architecture" *in nuce*.

Balla's Roman colleague Volt (Vincenzo Fani Ciotti) predicted that the earth would soon be covered by "a single city," and that "the harmony of the Futurist style will represent the synthesis of a thousand dissonances." If contemporary design is bound up with the drive to refashion material existence from "architecture to ashtrays," it finds a key early articulation not only in individual Futurist experiments, but the movement's wider reconceptualization of modern(ist) totality.

Chapter 6
Futurism and gender

Alongside the pledge to "glorify war" in Futurism's founding manifesto appears a no less infamous avowal: "contempt for woman." The line is followed by a promise to combat "moralism, feminism, and every utilitarian or opportunistic cowardice." These are no casual claims, but rather integral parts of the movement's early rationale. The Futurist pretention to virility hinged upon a suppression of the feminine in body and spirit. The movement's "frank misogynist optimism" aimed to defy an ostensibly emasculating cultural pessimism.

Futurist misogyny bore not upon the lives of particular individuals, Marinetti insisted, but rather the tired symbolism into which femininity was pressed in the abstract. As the scholar Lucia Re has noted, Italy bore no feminist movement of which to speak in the early 20th century, apart from a few isolated (and mutually exclusive) Catholic and socialist associations. "Feminism" thus served Futurism chiefly as a kind of rhetorical bugbear. To wit, the French poet and playwright Jane Catulle-Mendès expressed "a certain doubt about Monsieur Marinetti's scorn for women ... It appears to me that his pen is more brutal than his thinking."

For his part, Marinetti assured readers that it was indeed the "tyranny of love" at which he took true aim: the late Romantic, Symbolist, and Decadent platitudes which imprisoned

womanhood in an idealized metaphorics. No individual traded more in such idealizations than the nationalist writer and international ladies' man Gabriele D'Annunzio. Despite D'Annunzio's legendary womanizing—and equally because of it—the Futurists found his literary fixations mired in sentimental softness. Or so Marinetti argued, setting Futurism in opposition not to women, but to "woman" in D'Annunzian terms.

> We feel contempt for woman conceived as the reservoir of love, engine of lust, woman-poison, woman as a tragic bibelot, fragile woman, obsessing and fatal, whose voice, heavy with destiny, and whose dreamy tresses reach out and mingle with the foliage of forests bathed in moonlight....We feel contempt for horrible and staid Love that encumbers the march of man and prevents him from transcending his own humanity, from redoubling himself, from going beyond himself and becoming what we call multiplied man.

Paradoxically, the Futurist injunction against the feminine in the realm of sentimentalized metaphor was matched in the social sphere by a promotion of expanded rights.

The newfound prominence of Italian women in the labor force and cultural realm during World War I accelerated the discourse around civil liberties in a notoriously conservative, Catholic country. The Futurists were among the first to call for easy divorce, equal pay, and state-sponsored childcare. By 1918 the Futurist Political Party had made universal suffrage part of its official platform.

A degree of self-interest informed these moves. An increased female readership would help to bolster Futurism's propagation. The adherence to the movement of numerous female artists and authors—including Marinetti's own partner Benedetta Cappa—rendered its bombast about women all the more incongruous. Women of various social and geographic extraction enjoyed Futurist patronage and promotion well into the 1930s:

the sculptors Regina Bracchi and Růžena Zátková; the painters Marisa Mori and Barbara (Olga Biglieri); the photographer Wanda Wulz; the filmmaker Tina Cordero; the dancers Giannina Censi and Carla Ottolenghi; and the authors Rosa Rosà and Maria Ginnani, to name only some of the most prominent.

Anthologies and monographs published since the 1970s feature the work of hundreds of women affiliated with the movement. If these individuals had to navigate the minefield of Futurism's performative sexism, they also found in its ranks space for genuine professional development. Egalitarianism did not extend to Futurist rhetoric, however. Its texts describe academic painters as evincing an "effeminate fuss." Ostensibly effete critics are denounced as complacent pimps, like antiquarians who aim to "prostitute" Italy's patrimony; the city of Venice is decried as a "procuress" of archaic pleasures. Yet some of the same texts praise *actual* prostitutes (for ostensibly inciting men to courageous acts of violence), and the Futurists repeatedly invoked the brothel as a site of exhilarating modernity in defiance of bourgeois propriety. "[I]f the family should disappear, we could try to do without it," Marinetti notes in "Contempt for Woman."

Thus, on the one hand, he decried patriarchy to the degree that its trappings—conventional marriage and the familial unit chief among them—reproduced mediocrity at the expense of daring innovation. On the other, the Futurist concept of the "new man"—driven by the *Übermenschlich* vitalism of Nietzschean philosophy—excluded the feminine from its utopia except in the narrowest of senses.

For the most part, those senses were adumbrated by and for men. Deference to Fascism's increasingly reactionary attitude toward the family and childbearing saw the Futurists renounce their earlier support for female autonomy and non-reproductive sex in the 1920s. Over and against his paeans to "free love," Marinetti became a father and family man between the wars. Even still,

the movement provided ample forums for women at a time when female roles were mostly confined to the domestic realm. In short, the most consistent dimension of Futurist involvement of and attitudes toward women was its abiding inconsistency.

Marinetti not only disavowed "woman" as the enervating object of romantic fixation; he sought to obviate her role in reproduction, at least in a symbolic sense. If Nietzsche and other thinkers had mused about singularly male procreation, Marinetti made of this metaphor a whole narrative fantasy. Penned the same year as his Founding and Manifesto of Futurism—and forming a manifesto by other, fictional means—*Mafarka the Futurist* (1909) features a marauding North African autocrat who fashions a mechanical "son" from disparate materials and sheer will. This sculptural scion/construction foregrounds the demiurgic genius of the Futurist artist while also detaching the creative act itself from female biology. The protagonist's "Futurist Address" harangues his followers to transcend their destiny as "miserable sons of the vulva": "I tell you that the mind of man is an unpracticed ovary...It is we who are the first to impregnate it."

Mafarka's progenitive efforts (and noxious misogyny) prefigured a number of Futurist experiments. Perhaps most notably, the striding superman of Umberto Boccioni's *Unique Forms of Continuity in Space* (Figure 9) takes to heart Mafarka's exhortations to physicalize the (male) will, to "radiate will from your muscles and from your mouths...the willful, all-powerful mind must be externalized, in order to change the world!"

The Futurist artists did not practice these theories exclusively on representations of the male body, however. Some of Boccioni's most adventurous experiments instead took as their subject his own mother, most strikingly the hulking sculpture *Head + House + Light* (1912) and the large canvas *Materia* (1912–13) (whose title plays upon the Latin *mater* [mother] as a kind of primal matter). The *"Gran Madre,"* as Boccioni called her, served to demonstrate

Futurist interpenetration and simultaneity precisely in her hieratic passivity and cloistered domesticity—foils to the artist's evocations of dynamic male bodies and churning urban spaces. This sense of male propriety over female form extended to various media. Marinetti set about theorizing Futurist dance, even as those realizations depended entirely upon female performers (enacting a corporeal mimetism of machines).

Yet what of Futurist women artists and authors themselves? Many were affiliated with male artists personally. Boccioni's cousin Adriana Bisi Fabbri earned significant attention as a painter, just as Giacomo Balla's daughter Luce executed stunning tapestries based on her father's designs. Like the craftswomen in Fortunato Depero's studio—employed to help hand-weave a range of textiles—these individuals found their artistic identity eclipsed by the male artists in whose service they worked. Despite—or precisely because of—Futurist chauvinism, however, a number of women authors and artists responded to its macho imperatives on their own terms.

At the same time, many of these individuals undeniably—perhaps inevitably—internalized virility as the benchmark of women's contributions to the movement. The French polymath (dancer, poet, novelist, performer) Valentine de Saint Point responded pointedly to Marinetti with her 1912 "Manifesto of the Futurist Woman" (Figure 20), followed by a "Futurist Manifesto of Lust" the next year. In rejecting sexual difference—arguing instead for a spectrum of identities unfastened from biological determinism—Saint-Point anticipated elements of what we would today call non-binary gender. It is nevertheless the hypermasculine side of that spectrum that she privileged as the ideal, even of female subjectivity.

> WHAT WE MOST NEED, WHETHER MEN OR WOMEN, IS
> VIRILITY. That is why Futurism, with all its exaggerations, is right.
> To restore a certain virility to our races benumbed with femininity,
> we have to compel them to virility, even to brutality.

MANIFESTO
della Donna futurista

Risposta a F. T. MARINETTI

> « Noi vogliamo glorificare la guerra,
> sola igiene del mondo, il militarismo,
> il patriottismo, il gesto distruttore
> dei libertari, le belle idee per cui si
> muore e il disprezzo della donna. »
>
> *(Primo Manifesto del Futurismo).*

L'Umanità è mediocre. La maggioranza delle donne non è superiore nè inferiore alla maggioranza degli uomini. Esse sono uguali. Tutte e due meritano lo stesso disprezzo.

Il complesso dell'umanità non fu mai altro che il terreno di coltura dal quale balzarono i genii e gli eroi dei due sessi. Ma, nell'umanità come nella natura, vi sono momenti più propizi alla fioritura. Nelle estati dell'umanità, quando il terreno è arso di sole, i genii e gli eroi abbondano. Noi siamo all'inizio di una primavera; ci manca ancora una profusione di sole, cioè molto sangue sparso.

Le donne, come gli uomini, non sono responsabili dell'arenamento di cui soffrono gli esseri veramente giovani, ricchi di linfa e di sangue.

È assurdo dividere l'umanità in donne e uomini; essa è composta soltanto di **femminilità** e di **mascolinità**.

Ogni superuomo, ogni eroe, per quanto sia epico, ogni genio per quanto sia possente, è l'espressione prodigiosa di una razza e di un'epoca solo perchè è composto, ad un tempo, di elementi femminili e di elementi maschili, di femminilità e di mascolinità: cioè un essere completo.

Un individuo esclusivamente virile non è altro che un bruto; un individuo esclusivamente femminile non è altro che una femmina.

Avviene delle collettività e dei momenti dell'umanità come degli individui. I periodi fecondi, in cui dal terreno di coltura in ebullizione balzano fuori in maggior numero genii ed eroi, sono periodi ricchi di mascolinità e di femminilità.

I periodi che ebbero solo delle guerre feconde d'eroi rappresentativi, perchè il soffio epico li livellò, furono periodi esclusivamente virili; quelli che rinnegarono l'istinto eroico, e che, rivolti verso il passato, s'annientarono in sogni di pace, furono periodi in cui dominò la femminilità.

20. Valentine de Saint-Point, *Manifesto of the Futurist Woman*, *A Response to F. T. Marinetti*, March 25, 1912, University Library of Padua.

Saint-Point's fiery responses forced Marinetti to take women seriously as contributors to Futurism. Even still, she believed his misogyny could be countered most persuasively by *physical* prowess, by "warriors who fight more ferociously than

men...destroyers who contribute to racial selection by smashing the fragile." Her theory of female "Futurist lust" likewise insisted upon corporeal "force" as a means by which to combat fatal sentimentalism: "to kill the weak and raise the strong."

Saint-Point's ideas bear parallels with the contemporary work of British-born poet, painter, and novelist Mina Loy, whose strain of Futurist-feminism echoed the anti-democratic Nietzscheanism of Marinetti (of whom she was the lover for a time), while wresting from it an exuberant liberation from bourgeois mores. Loy verbally challenged Marinetti on a number of occasions, pointing out his paradoxical dependence upon the very crowds that he claimed to manipulate. Her "Feminist Manifesto" (1914) insists upon the creative force of female pleasure and the dismantling of gender constructions, along with a parliamentary system that essentially institutionalized patriarchy. Yet in the same breath (or breathlessness, given her effervescent text's lack of punctuation) Loy insists upon the "race-responsibility" of women in having and raising children.

Such viewpoints reflect a wider internalization of patriarchal mores, even as Futurist women embraced the defiance of bourgeois morality. Extolling the gains made for women during the Great War, the writer and painter Rosa Rosà (née Edyth von Haynau) argued that Italian femininity had earned new social standing by virtue of a propitious virilization. The actor and author Enif Robert responded in the same vein to the rabid chauvinism of her male peers, arguing that the inferiority of women could be mitigated by proving in their turn "strong, VIRILE, INTELLIGENT, alongside their man."

At the same time, Rosà pushed back against Futurist misogyny in a number of incisive articles, and her 1918 novel *A Woman with Three Souls* (*Una donna con tre anime*) carved out new subject positions—intellectual and erotic—for the Futurist woman. For her part, Robert published the collage novel *Una ventre di donna*

(A Woman's Womb) in 1919 under both her own name and that of Marinetti: an authorial equality reflected in the mounting participation of women in the movement's journals. Co-edited by the writer Maria Ginnani, the journal *L'Italia Futurista* featured a cadre of regular female contributors (including Rosà and Roberts), several of whom merged Futurist preoccupations with occultism and spiritualism, notably anticipating Surrealist pursuits in France between the wars.

A growing number of Futurist women actively challenged the often peremptory interventions made by male counterparts. Published by the poet and journalist Volt (Vincenzo Fani Ciotti) in *Roma Futurista* (the movement's chief political organ after the war), the "Manifesto of Futurist Women's Fashion" (1919) demanded an aesthetic "revolution" modelled on male precedent:

> It will suffice to see multiplied by a hundredfold the dynamic virtues of fashion, shattering the restraints which prevent its full flourish, soaring over the serrated vertigo of the Absurd...In sporting these newest styles of apparel, the Futurist woman will need to display the same courage that we demonstrated upon declaiming our *words-in-freedom* against the intractable idiocies of Italian and foreign audiences.

Identifying herself as "A Futurist for nearly seven years," one reader wrote to the journal to express her admiration for Volt's ideas, but also to contest their social and economic implications. She aims her response not merely at the author and his confrères, but to fellow female *Futuriste*:

> In the name of real Futurist women (who are indeed 'feminist'), I thank you for what you have written about the question of gender with such good sense...[Yet] the real Futurist is simply a woman who prefers to starve to death than to be kept by a man....[She] will not be able to afford the latest fashions, or elegant shoes, nor visits to the cosmetics shop. The woman who has to look after

> herself won't have time for flirting.... Don't fool yourselves, my dear
> Futurist sisters, the life of a woman who fends for herself is not
> *la vie en rose*. One needs courage to survive!

Several "real Futurist women" indeed made their mark independent of any man. A former student of Balla, the Rome-based Czech artist Růžena Zátková completed a large sculpture in 1916 which she titled *Sensibility, Noises and Rhythmic Forces of a Pile Driver* (1916): a meter-high assemblage wrought from leather, metal, fiber, and glass. Zátková traced its inspiration to a steam-powered machine which daily pounded the ground near her studio, and remarked that she felt compelled to sketch a concept for the work "as when a child is born."

A chorus of male commentators rushed to confirm the significance of that metaphorical birth. Enrico Prampolini hailed the "superb virility" of her *Pile Driver*; Marinetti deemed its "virile ingenuity" a "typical Futurist feat of strength and maculinity." Describing her imagery as evincing "psychic situations difficult to express in words," Zátková proved a more nuanced expositor of its meanings than male peers, who instead rushed to recruit its evocations for their own agenda. The rotational and organic elements of the artist's Painting-Sensation series (Figure 17) resonated with her self-understanding vis-à-vis Futurism. "For me," she wrote to the Russian painter Mikhail Larionov in 1920, "Futurism is a circle and I am a spiral. I am made entirely of circles, but open circles..."

Zátková's partner Arturo Cappa was the brother of Benedetta—wife of Marinetti, mother of his three children, and perhaps the most prominent female Futurist of all. Alongside familial duties, Benedetta worked as a novelist, poet, ceramicist, and one of the most gifted painters of Futurism's interwar years, completing a stunning set of murals for Palermo's post office (1933–34) dedicated to the theme of modern communication. Her paintings *Speed of a Motorboat* (1923–24) and *The Great X* (1931) (Figure 21) effortlessly merge geometric faceting and swollen curvilinear

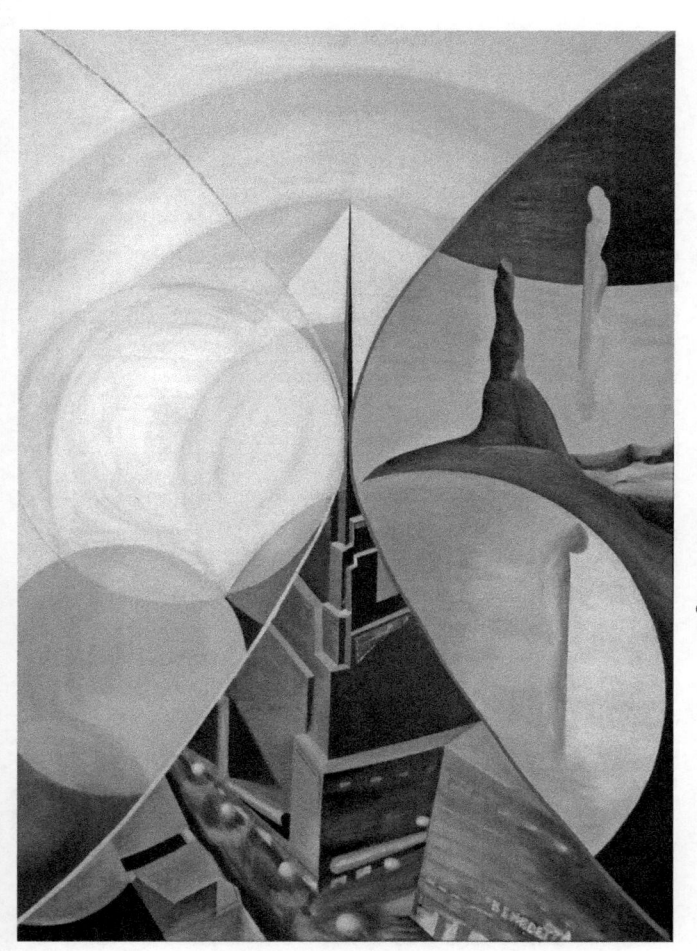

21. Benedetta Cappa Marinetti, *The Great X*, 1931, oil on canvas,
50 3/4" × 35 7/16". Musée d'Art Moderne de la Ville de Paris.

forms—a style she would set to productive use in the 1930s "aeropainting" movement, of which she was a leading exponent.

Benedetta refused to let her writings be molded in Marinetti's image, and scholars have demonstrated the extent to which she influenced his later output. Juxtaposing narrative and "graphic syntheses" in a playful interaction of word and image, her 1924 novel *Le forze umane* (*Human Forces*) at once signaled her official adherence to the movement and flouted some of its tenets, embracing elements even of Dutch Neoplasticism. On the surface, Benedetta's later writings on the issue of maternity under the Fascist regime reaffirm the state's repressive gender roles; yet some of the same texts render womanhood central to creation—cultural as well as biological—in modern life.

This is not to say that her work or that of other Futurist women proves unequivocally progressive by virtue of their authors' gender. In 1932 Benedetta penned a "Futurist Recruitment Project for the Next War" which anticipated a "future aerial-chemical" conflict—one whose waging could be incentivized, she wrote, by offering older citizens a "useful death on the battlefield instead of a sad death in their beds." A few years later during the brutal campaign in the Horn of Africa by Mussolini's army in 1935, her text "Spirituality of the Italian Woman" exhorted women to exploit the war to better their social standing—an advancement not extended to their female Ethiopian counterparts. Dressed in uniform, Benedetta rallied women to the cause of Italy's brutal invasion and occupation.

Its unprecedented aerial attacks had been rehearsed in a range of "aeroaesthetic" media, in which many women artists had participated—even as the female body was objectified and eroticized back home by male Futurist counterparts, including as "propellers" in dance or in paint, in keeping with Futurism's aerial fixations. The aeropainter Alfredo Ambrosi extolled the "fertile female womb" and "spiral-vulva-propeller" of the ideal woman—a

mixing of metaphors made wincingly literal in his aeropainting *Nativity* (1930). Performances by the "aerodancer" Giannina Censi came to figure into a Fascist manual on physical culture (*Physical Culture for Women and Female Aesthetics*; *Cultura fisica della donna ed estetica femminile*, 1933), which codified the reproductive capacities of Italian women. Censi's "aerodances" interpreted aeropaintings by Prampolini, who held his canvases aloft as she enacted their imagery, wielding metal tubes and pipes (Figure 22). The embodiment of Futurist dance thus deferred to the primacy of painting, just as the female artist remained subordinated to male fantasy.

From the start, Futurism's hypermasculine ethos engendered a homosocial fraternity of creators. Reactions to the homoerotic potential (or "homosexual panic") of that circumstance were less straightforwardly homophobic than might be expected, at least early on. Decrying the bourgeois puritanism of the English to an audience at London's Lyceum club in 1912, Marinetti reminded his listeners of the "dismal, ridiculous condemnation of Oscar Wilde."

> As for your 20-year-old young men, almost all of them are homosexuals for a time, which, after all, is absolutely respectable. This taste of theirs evolves through a kind of intensification of the camaraderie and friendship found in athletic sports in the years before they turn 30, the time for work and good order, when they show their heels to Sodom in order to marry a young woman whose gown is shamelessly décolleté. Then they hasten to condemn the born invert severely, the counterfeit man, the half-woman who fails to conform.

Such remarks hardly signaled a dedication to homosexual rights. They served largely to mock English "prudishness" and "conventional morality."

Yet Marinetti remained relatively consistent in his public defenses of homosexuality, at least with regard to individuals he knew

22. Giannina Censi in *Espressioni e studio di movenze figurazione bacchica ottenuta coll'estremo movimento delle gambe e delle braccia* [Expressions and study of movements, figuration obtained with the extreme movement of the legs and arms], *c*.1933.

personally. He supported the Futurist-affiliated author Aldo Palazzeschi, for instance, who, apart from the prominent novel *Il codice di Perelà* (*Man of Smoke*, 1910), authored homoerotic verse and privately acknowledged to Marinetti his own sexual tendencies. One of Palazzeschi's (non-Futurist) sonnets titled "La cigarette" centers upon a young man longingly contemplating the lips of another man whom he desires to kiss—a very different "man of smoke" than his widely publicized novel.

The ambient smoke in Ardengo Soffici's *Dance of the Pederasts (Plastic Dynamism)* (1913) (Figure 23) underscores the ambiguity of the painting's affect and meaning alike. Striking a queer—and perhaps even empathetic—note, the image plunges the viewer into the half-light of a raucous *café chantant*, with two barely discernible male figures seated together. Soffici described the work in the prominent journal *Lacerba* as "absolutely modernist-Futurist!," and wrote to Carlo Carrà that he felt it formed his "first truly Futurist canvas." In the right foreground appears a copy of Italo Tavolato's book *Contro la morale sessuale* (*Against Sexual Morality*)—published this same year and proclaiming that there was "nothing more natural than pederasty."

Like Tavolato's contemporary *In Praise of Prostitution* (1913), the text assailed bourgeois morality and biological positivism alike—an effort which saw the author, who was active in Florentine Futurism, charged with public indecency. Tavolato's defense of "pederasty" alongside prostitution formed a tacit, oblique justification of his own partially closeted homosexuality—which the Fascist secret police eventually turned to their advantage, employing Tavolato (under certain duress) as an informant during the 1930s.

For the most part, "pederasty" (as homosexuality was generally referred to at the time) appears in Futurist works in an insidious light. Non-heterosexuals are predictably lumped together with women as threats to masculine supremacy. Notwithstanding his defense of Wilde and support of Palazzeschi, Marinetti indulged

SOFFICI. — Ballo dei pederasti *(Dinamismo plastico)* (1913) Danse des pédérastes *(Dynamisme plastique)*

23. Ardengo Soffici, Dance of the Pederasts (Plastic Dynamism), oil on canvas, 1913 (destroyed).

in the same tropes. In a narrative shot through with xenophobia and anti-Semitism, his 1918 "erotic-social" novel *L'isola dei baci* (*The Island of Kisses*), co-authored with Bruno Corra, depicts a group of international literati on the isle of Capri whose all-male "congress" seeks to banish women in favor of a pacifist homosexual "religion." His manifesto "Against Feminine Luxury" (1920) concludes in more prosaically proscriptive terms:

> In the name of the great, fecund, virile and genius Italy of the
> future, we Futurists condemn the rampant feminine idiocy and the
> servile male imbecility which together contribute to feminine
> luxury, to prostitution, to pederasty, and to the sterility of the race.

Even the (relatively) openly homosexual painter Gino Galli, in a
manifesto from the same year, proclaimed the need to eliminate
the "effeminate...influence of foreign art" from Futurism's
pictorial language.

In the wake of World War I's mass destruction, feminine
indulgence and "pederastic" superfluity smacked of more than
avant-garde eccentricity. They bore upon the nation's perceived
health and strength. Obsession with the fecundity of the Italian
"race" grew into a cornerstone of Fascist policy; by 1927 natalist
measures were in full swing. Officials began levying nearly
double income tax rates on unmarried men—further (pecuniary)
penalty for (moral) deviation. Conversely, the rewards offered to
fertile mothers—increased benefits, tax remissions, public
honors—enshrined into bureaucratic pomp a cultural obsession
with virility.

That obsession was exacerbated by Futurist aesthetics and
rhetoric. To be sure, Fascist gender politics travestied early
Futurist tropes as much as they reinforced them. Despite the
undeniable consonance between Marinetti's bluster and
Mussolini's bravado, the "reproductive futurism" of state-
sponsored biopolitics strayed from the movement's original
pledges to increase individual liberties, to obviate the traditional
family, and to propagate *amore libero*.

Chapter 7
Futurisms, plural

First sketched sometime in the late 1920s and updated as late as 1939, F. T. Marinetti's "Concise Chart of Italian Futurism" (Figure 24) renders the movement as a streamlined tree. From its trunk sprout branches of nearly a dozen European avant-gardes from Suprematism to Surrealism, Expressionism to Purism, Orphism to Dadaism, Vorticism to Constructivism. Marinetti's genealogy omits Cubism except in its literary manifestations, subsumed under the primacy of Italian innovation. That Futurist artists had adapted visual strategies from the Cubists after a visit to Paris in the autumn of 1911 is indisputable, even by their own account. Their assimilation of its angular faceting—a consummately modern method for evincing the effects of spatial interpenetration and temporal flux—overhauled Futurism's competent but outmoded post-Impressionism. Boccioni's sculptural experiments and Balla's prismatic abstractions, for instance, would likely never have developed independently of Cubism's formal innovations.

Yet it is not on formal terms that Marinetti staked his movement's chief claim to consequence. Though a few Cubists had tried their hand at architectural and interior design, for instance, the tendency remained bound up almost exclusively with painting and sculpture. And if the Russian Constructivists pushed past easel painting in the 1920s to cultivate media from photography to

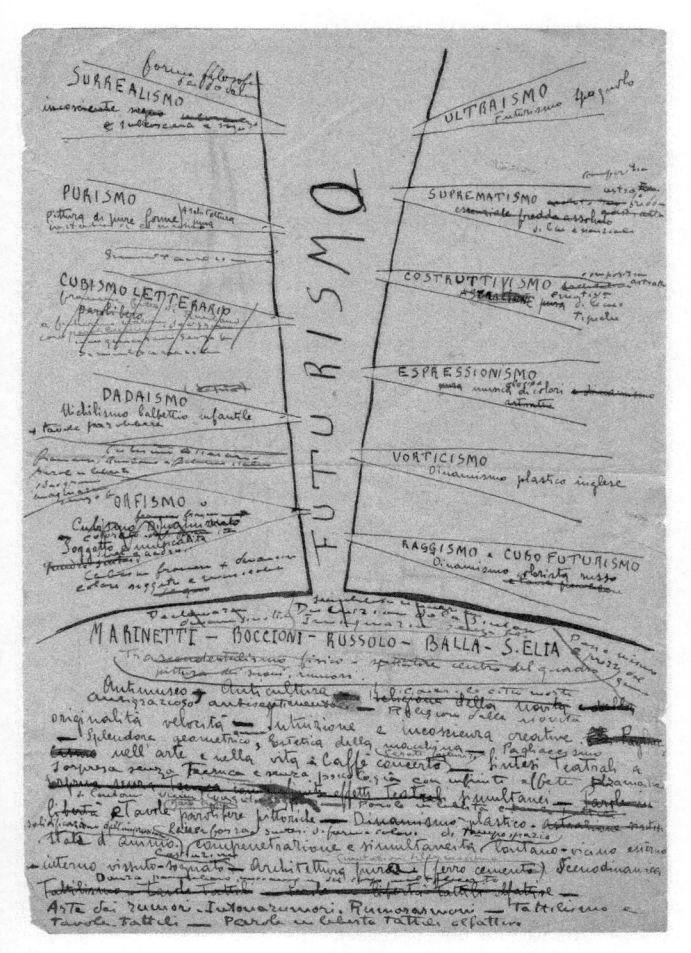

24. F. T. Marinetti, "Concise Chart of Italian Futurism and the Avant-Garde," with corrections and amendments, Marinetti notebooks, Beinecke Library, Yale University, Box 57, Folder 202.

clothing design, it was Futurism's lead that they followed. Already by the mid-1910s Futurism could boast of manifestos on—and experiments in—photography and dance, politics and music.

Boasting of accomplishments formed one of Marinetti's key preoccupations—a further, performative facet of his movement in its own right. In a dispatch of August 1915 he announced:

> With millions of manifestos, books, and pamphlets in every language... with more than eight hundred lectures, exhibitions, and concerts, we imposed the predominance of our creative and innovative Italian genius over the creative genius of other races throughout the world and especially in Europe.

He would continue over the years to inflate such statistics with valedictory arrogance. Yet as an all-encompassing avant-garde—armed with a theoretical program, a prodigious publicity campaign, and an ever expanding practice in seemingly limitless media—Futurism unarguably broke new ground.

Already with the manifesto "Exhibitors to the Public" (February 1912) Boccioni and his peers sought to differentiate Futurist imagery from the "masked academicism" of Cubist imagery. Notwithstanding the Futurist insistence on the significance of evoking speed and movement, such dimensions are not always so easily distinguished from Cubist counterparts—hardly surprising given the interchange of respective techniques at the time.

The portmanteau "Cubo-Futurism" attests to those correspondences already by 1913, applied to work by Russian painters such as Alexandra Exter, Lyubov Popova, and Ivan Kliun, and others who merged elements of both tendencies. Like Kasimir Malevich's *The Knifegrinder* (1912), Natalia Goncharova's painting *Cyclist* (1913) (Figure 25) exemplifies precisely this inflection of Cubist geometries with Futurist evocations of movement, motion,

25. Natalia Goncharova, *Cyclist*, 1913, oil on canvas, The State Russian Museum, St. Petersburg.

and speed, particularly in an urban setting. Whatever their admiration for the *stylistic* revolution of Cubism, modern artists of all stripes were forced to confront the ideological bravado (and relentless publicity) of Futurism, whether in affinity or antagonism.

A mix of both greeted Marinetti in Moscow and St. Petersburg, where debates over Futurism roiled the popular press and artistic circles. Uniting the poets Vladimir Mayakosky, Aleksei Kruchyonykh, and Velimir Khlebnikov with painters like Malevich, Goncharova, and David Burliuk, the 1912 manifesto "A Slap in the Face of Public Taste" leavened an autochthonous Russian and Ukranian avant-gardism with ideas adapted from the Italians. This same year saw Goncharova found the Rayonist movement with her partner and fellow painter Mikhail Larionov. An accompanying manifesto—itself inspired by Futurist examples—articulated the painters' aims: to represent not objects

or bodies but rather the rays emanating from them. The Rayonists' jagged, crystalline abstractions drew upon Futurist evocations of dynamic movement; but so too did the desire to erase "the barriers between the pictures' surface and nature"—a conception of the canvas as a way station between aesthetics and actuality.

The Italian influence appeared reflected in Russian typographic variations and confrontational performances, aimed to shake up the conformity of bourgeois culture ("the filthy stigmas of your 'common sense' and 'good taste'") along with the social inequalities they veiled. "Throw Pushkin, Dostoevsky, Tolstoy, etc., overboard from the Ship of Modernity," the signatories urged their contemporaries. "The only freedom we demand," Khlebnikov would write in 1914, "is freedom from the dead, i.e., from all these gentlemen who have lived before us." A growing number of Russian artists and authors disavowed Marinetti as the arbiter of such freedom. Yet their experiments notably persisted under the banner of "Russian Futurism," reflecting the impact of the Italian avant-garde.

In a related vein, the English Vorticist leader Wyndham Lewis—himself no servile imitator of Marinetti—deemed Futurism "one of the alternative terms for modern painting." The Greek-born Italian writer and musician Alberto Savinio—the polar opposite of Marinetti in his aesthetic sensibilities—likewise conceded the movement's catch-all anti-academicism, joking that "every artist who was not a fool was a Futurist." Even the French critic Apollinaire—who had openly criticized Marinetti's group of painters in 1912—made common cause with Futurism as "a motor for all tendencies" with his fiery "Futurist Anti-Tradition" manifesto in 1914. For a time, in Italy and abroad, the name Futurism thus signified almost any engagement with modernism at the expense of convention.

The movement's nominative singularity belied internal divisions, however. Marinetti's stridency alienated a range of fellow travelers

within Italy itself—even those who endorsed the Futurist revolt against bourgeois propriety. Fittingly enough for a movement premised upon the necessity of violence, such divergences occasionally took physical form. A negative review of the Futurists' work in June 1911 saw the Milan-based artists take the train to Florence to rough up the author of the article in question. Ironically (or not), the target of their blows—the critic and painter Ardengo Soffici—ended up joining the movement, along with the philosopher and critic Giovanni Papini, the writer Aldo Palazzeschi, and other Florentine avant-gardists.

Soffici's ties with French culture supplemented those of the Paris-based Severini, and lent the group further critical clout. Anchored by the influential journals *La voce* (1908–16) and *Lacerba* (1913–15), and cemented by a shared commitment to irredentism and interventionism, the collaboration between the Florence-based Futurists and Marinetti's circle resulted in a rich discourse transcending narrowly Italian preoccupations. Picasso, Apollinaire, and Stéphane Mallarmé counted among *Lacerba*'s contributors.

The two camps would nevertheless fall out by early 1915, with Carrà and Severini defecting to the Florentine camp. An article titled "Futurism and Marinettism" detailed the unbreachable distance between different interpretations of the movement. Against Marinetti's "chauvinism" and "militarism" Papini, Palazzeschi, and Soffici proposed "patriotism" and "combativeness." Proclaiming the "Latinity" of their own Futurism, they disavowed the "Americanism" and "Germanness" of Marinetti's ilk. Such a characterization resonated with extra vitriol in the wake of widespread anti-Austrian and anti-German sentiment stirred up by the war. Yet it also revealed the genuinely international reach of Marinetti (dubbed "the caffeine of Europe"), his loudmouthed chauvinism notwithstanding.

It was at Herwarth Walden's Der Sturm Gallery in Berlin (spring 1912) and Otto Feldmann's gallery in Cologne (fall 1912) that

many European artists first saw works like Balla's *Dog on a Leash* and Boccioni's *Unique Forms of Continuity in Space*—encounters which would shape the trajectories of German painters like George Grosz, Max Ernst, and Auguste Macke. Walden himself translated a good amount of Futurist manifestos and publicity materials, though critics mostly recoiled from Futurism in the German press. By contrast, an artist like Franz Marc satirized the prejudices of what he called "Picasso collectors" in their failure to grasp the implications of Futurist theory and practice. He gnomically cited a Japanese proverb to gloss the upshot of Boccioni's *The Street Enters the House* and other related paintings:

> 'If you open a window, all the noise of the street, the movements and the physicality of things outside suddenly enter the room.'...Carrà, Boccioni, and Severini will form milestones in the history of modern painting. We will once again envy Italy her sons and hang their works in our galleries.

For the writer Alfred Döblin, Futurism represented "an act of liberation," manifest in the kaleidoscopic frenzy of his own ground-breaking novel *Berlin Alexanderplatz* (1929). "I'm not one for lofty or pompous words," Döblin remarked in the journal *Der Sturm* in May 1912, "But I subscribe to Futurism wholeheartedly and give it a resounding 'yes.'"

Aside from the generic "Americanism" of Futurism's urban fixations, a few actual artists from the United States rallied to its ranks. Having exhibited in 1913 at the Armory Show (from which the Futurists were notably absent), the painter Frances Simpson Stevens moved to Italy and declared herself a convert to the movement. The sole American artist represented at the "First Free International Futurist Exhibition" in Rome in 1914, she exhibited eight works alongside the British-born artist and writer Mina Loy (another figure in Futurism's orbit at the time) from whom Stevens rented a studio in Florence. Upon the war's outbreak Stevens returned to the United States and exhibited works like

Dynamic Velocity of Interborough Rapid Transit Power Station
(1915), before fading entirely from view.

A single issue of the journal *Futurist Aristocracy* appeared in New
York in April 1923, publishing two of Marinetti's manifestos in
English alongside paintings by American artists Charles Sheeler
and John Marin. By this date the movement's presence had all but
receded on American shores. For several years its most prominent
exponent remained the Italian-born painter Joseph Stella, who
had met the Futurists during a pre-war trip to Paris. Though
he never exhibited alongside the artists, Stella became their
chief emissary in the United States, with works from the
phantasmagoric *Battle of Lights: Coney Island, Mardi Gras* (1913)
to his crystalline opus, *Brooklyn Bridge* (1919–20) (Figure 26).
Stella maintained a close rapport during these same years with
New York Dada and especially Marcel Duchamp, whose *Nude
Descending a Staircase, n. 2* (1912) had erroneously been mistaken
by American audiences at the Armory Show as a "Futurist"
painting. Such simultaneous affinities underscore the frequent
overlaps among avant-gardes at the time, and set into further relief
the complex relationship of Futurism to the Dadaist movement.

Launched in neutral Switzerland amidst the hysteria of war in
1916, Dada put Futurist tactics to use in its raucous soirées and in
the typographic experiments of its eponymous journal, to which
several Italians contributed. The exuberant pacifism of Zurich
Dada adapted Futurist strategies while undermining its bellicose
ideals. The Italians' *serate*, or evening performances, inspired
similarly rowdy events by the more decidedly international
Dadaists gathered in Zurich. Reading "simultaneous poems" at the
Cabaret Voltaire, the latter sought to shatter the encrusted
comforts of language, just as their Berlin-based counterparts used
assemblage, photomontage, and public performances to assail the
very institution of art. The babelic internationalism of a poem like
The Admiral is Looking for a New Home (1916)—recited
simultaneously by Tristan Tzara, Richard Huelsenbeck, and

26. Joseph Stella, *Brooklyn Bridge*, 1919–20, oil on canvas,
84 3/4 × 76 5/8 in. (215.3 × 194.6 cm), Yale University Art Gallery.

Marcel Janco in three different languages (not necessarily their
own)—parodied both the current war and the nationalism fueling it.

Futurism aimed to comprise everything in an all-encompassing
aesthetic enterprise; the Dadaists instead proclaimed themselves
partisans of nothing. Tzara's 1918 Dada Manifesto announced:

> Dada was born of a need for independence, of a distrust towards
> unity. Those who are with us preserve their freedom. We recognize
> no theory. We have enough Cubist and Futurist academies:

laboratories for formal ideas. Is the aim of art to make money and to cajole the nice nice bourgeoisie? ... Let each man proclaim: there is a great negative work of destruction to be accomplished. We must sweep and clean.

Even—or precisely—as he declared himself "against manifestos," Tzara borrowed from the Futurist rhetoric of demolition. Other Dadaist groups likewise drew upon the violence of Futurist strategies while exchanging aesthetic idealism for a contestatory nihilism.

The Futurists had distinguished themselves from Cubist artists as transcending formalist preoccupations; Dadaists in turn regarded Futurism as an abidingly object-oriented avant-garde—one still wed to the cultural currency of painting and sculpture. Caught up in the tumult of the Spartacist Revolution, and rejecting the traffic in art commodities as a symptom of bourgeois barbarism, Berlin Dada took far more seriously than Marinetti's crew the Futurist call to "spit on the Altar of Art."

By contrast, the English Vorticist movement echoed Futurist screeds against "passéism" while similarly remaining invested in the institution of painting. Marked by equal parts hectoring aggression and charm offensive, Marinetti's early visits to London stirred up significant interest. "I am an Italian Futurist poet and I love England," he announced in a 1914 manifesto co-written with the English painter Christopher Nevinson, whose attempts to convert his countrymen saw them found the Vorticist group in proud defiance. The bold typography and peremptory rhetoric of the wartime Vorticist journal *BLAST* (1914–15) (Figure 27) betrayed Futurist inspiration even as its authors—Wyndham Lewis chief among them—distanced themselves from what Lewis called Marinetti's "pedantic propaganda." In visual terms, the Vorticists also opposed the Futurist penchant for atmospheric "interpenetration" (a legacy of Cézannian *passage*). They pursued more crisply defined lines and angles evocative of an

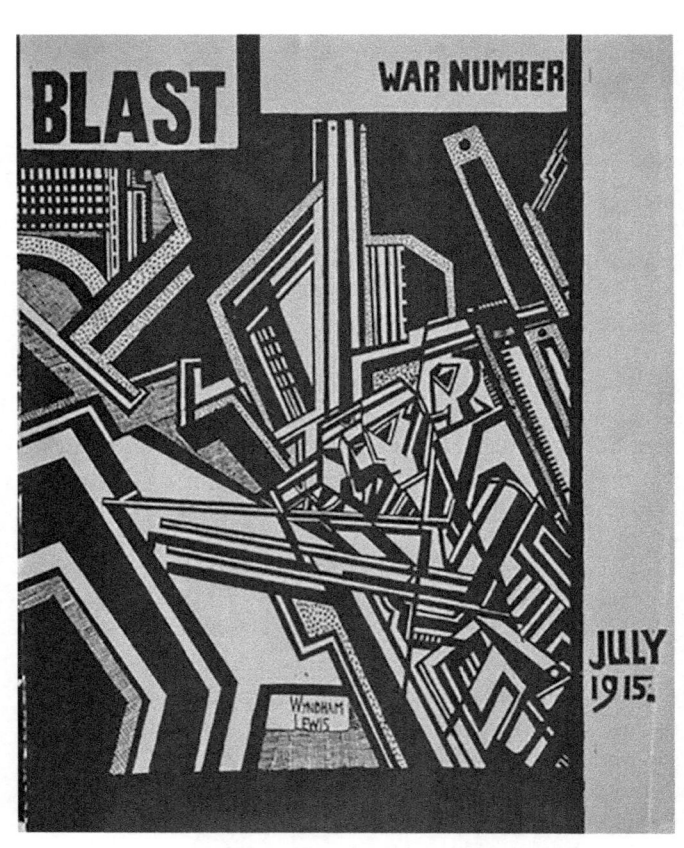

27. *BLAST*, no. 2, War Number (July 1915), London, 1915.

unsentimentally mechanized metropolis, free of the "fuss and hysterics" which they attributed to Futurist form.

The Vorticists formed just one group among dozens featured in the sprawling exhibition *Futurism & Futurisms* mounted in Venice in 1988. Comprising artists from Poland, Mexico, Portugal, Sweden, Hungary, France, Japan, and other nations, its

interpretation of Futurism as a global phenomenon was presented as entirely compatible with the movement's Italian impetus. The exhibition's very title still conjures up relevant questions of taxonomy. Is Futurist imagery by any other name still Futurist? What qualifies a painting or sculpture or a work of architectural design as such? Is subject matter the determining factor, or else style? Or is it instead a more ineffable sense—or sensibility—of early 20th-century agitation?

For his part, Marinetti found all publicity good publicity. Even as his 1920 tract "Beyond Communism" rejected Marxism as detrimental to individual expression, he announced his delight that "Russian Futurists are all Bolsheviks and for a while Futurist art was the official Russian art. On May Day of last year the Russian cities were decorated by Futurist painters." By such logic, the revolutionary futurity of Futurism could be seen to bridge even the widest of ideological divides.

Mussolini's regime exacerbated that divide even as it sidelined Marinetti's efforts throughout the 1920s and 1930s. Futurism found itself increasingly embattled on the home front against ever more reactionary forces. Yet it also risked (and courted) conflation with Fascism in its reception abroad. Paradoxically or not, its international activity increased in tandem with mounting pledges to state service in the 1920s. Running until 1925, Enrico Prampolini's journal *Noi* featured work by Kseniya Boguslavskaya, Vilmos Huszár, Theo Van Doesburg, Friedrich Kiesler, and Vladimir Tatlin, to name only a few of its foreign contributors. Alongside the Italian names listed in the periodical *Vetrina Futurista* in 1927 we find Herwarth Walden, Michel Seuphor, and Paul Dermée, in addition to "associates" Albert Gleizes, Fernand Léger, and Wassily Kandinsky. The journal's last page advertises over 20 "Futurist Periodicals" from well beyond Italy's borders: *Stavba*, *Plasmo*, and *Disk* in Prague; *De Stijl* and *l'Esprit Nouveau* in Paris; *Inicial* in Buenos Aires; and *Mavo* in Tokyo.

The claim to such journals as "Futurist" overreaches. Indeed, the movement pitched its tent ever wider as its actual influence diminished. Marinetti sponsored foreign-language mouthpieces throughout the 1920s and 1930s to stoke the waning embers of Futurist relevance. Helmed by the poet Ruggero Vasari in Berlin, *Der Futurismus* covered trends in painting and sculpture—particularly among Mitteleuropean artists—assimilating them to a Futurist rubric. A translation of Marinetti's "Tactilist" manifesto, for example, appeared improbably illustrated in one issue with works by the German and Latvian sculptors Rudolf Belling and Karl Zalit (Kārlis Zāle).

A few Eastern European avant-garde luminaries obliged these efforts. Karel Teige's Prague-based, multilingual journal *ReD* (*Revue Devětsilu*, 1927–31), for example, dedicated a special 1929 issue to "World Futurism." Marinetti clung ever more desperately to that appellation, placing every avant-garde phenomenon—both retroactively and proleptically—under its aegis, including even "*Futuristes sans le savoir*" ("unwitting Futurists"). "All the Futurisms of the world are the children of Italian Futurism," he insisted, conceding *en passant* their respective sovereignty: "All Futurist movements are nevertheless autonomous. Every people has had, or still has, its passéism to overthrow."

The benign paternalism of such a statement masks more insidious factors. Along the country's northeastern border, for instance, Fascist linguistic and cultural imperialism increasingly squeezed the autonomy of Slovenian and other Yugoslav avant-garde groups. Members of the Triestine Constructivist Group had fruitfully exchanged ideas and ambitions with Futurist counterparts until the mid-1920s; by the decade's end they found themselves subordinated to the strictures of Fascist art syndicates, to say nothing of the regime's mounting repression of Slavic cultural identity.

Marinetti's xenophobic gambits could only exacerbate such circumstances. His caustic 1931 manifesto "Contro l'esterofilia"

("Against Foreigno-philes") announced an "adamantine patriotism" while denouncing those citizens whose fondness for anything foreign rendered them treacherously "anti-Italian." His own movement found itself in turn embattled against virulently racist factions, who saw in Futurist "cosmopolitanism" proof of anti-Italian degeneracy.

When in 1932 the Bauhaus risked closure due to Hitler's rise, Kandinsky wrote to Marinetti for assistance as a fellow avant-garde traveler. Though the latter proved sympathetic, his responses to Fascist anti-Semitism at home abetted noxious stereotypes rather than refuted them. In an open letter to Hitler in 1937, Marinetti denied that Jews had contributed to the Futurist movement except as merchants of its objects. To be sure, he criticized the Nazi campaign against "Degenerate Art" and argued vehemently against its importation to Italy. He publicly rejected the curtailment of artistic expression entailed in Nazi policy, and privately doubted the wisdom of a close alliance with Germany.

Yet Marinetti's desire to perpetuate Futurism in the teeth of cultural reaction trumped any meaningful act of dissent. A return to his native Egypt in 1938 saw him deliver a series of lectures at Cairo's Les Essayistes club, the pro-Fascist propaganda of which sparked protests by a group of foreign-born and Egyptian artists led by Georges Henein. Their ensuing manifesto "Yahya al Fan Al Fan Al Munhat!/Vive l'art dégénéré!" both embraced the Nazi anathema of "Degenerate Art" as a badge of honor and launched an Egyptian Surrealist movement—in defiance of the "abject aggression" against modern art by totalitarian regimes.

Marinetti and his followers had set no geographic limits to the expansion of "World Futurism." Indeed, they considered its propagation merely to confirm a fundamentally Italian genius. The group's wholly xenophobic retrenchment in the late 1930s and early 1940s—in concert with a politics of imperial conquest and war—recast its "universal" ambition in a more sinister light.

Yet despite the dubious colonialist fantasies marking some of its early iterations, Futurism shifted modernist activity away from the unrivaled primacy of Paris. A gradual decentering of 20th-century Western culture began with Futurism's internationalization of the avant-garde: a globalized aesthetics and aesthetics of globalization with still ambivalent repercussions in the present.

Chapter 8
"Second" Futurism and the Fascist regime

"The possibility of a Futurist architecture perished with [Antonio] Sant'Elia in 1916 just as the development of Futurist painting expired, for certain, with the death of [Umberto] Boccioni the same year."

Thus reads a line from Reyner Banham's landmark volume *Theory and Design in the First Machine Age* (1960). Limiting Futurism's aesthetic fortunes to a few "heroic" years, Banham's account reflected widespread consensus in Italy and abroad. For, though the movement lasted until 1944, its activity between the world wars became routinely excluded from the province of scholarship—or even general recognition—until the early 1960s. Whenever historians did concede Futurism's full extent, they divided it into two mutually exclusive phases: a first innovative and revolutionary period, followed by a derivative and reactionary one.

Even Alfredo Moretti's 1939 book *Futurismo*—the first study of the movement authored from outside its own ranks—mainly treated works made before 1914, even as Futurism remained in full swing at the time of his writing. By 1972, the Italian art historian Maurizio Fagiolo Dell'Arco would proclaim it "evident that Futurism was not a movement confined only to Italy and to a single decade, but was a veritable storehouse of plans for a

permanent artistic revolution." Yet Fagiolo himself notably persisted in delimiting the "true boundaries" of the Futurist project from 1909 to 1919.

The rationale for such a historiographic partition was plain. Futurism's associations with the Fascist regime after the early 1920s—both real and perceived—threatened to taint even its earlier achievements with noxious ideological compromise. Despite Marinetti's private misgivings about his alliance with Mussolini's government—and in spite of the latter's ambivalence toward Marinetti and Futurism—the movement's extensive efforts on Fascism's behalf sealed their affiliation in collective memory. By cordoning off the movement's "first" iteration from a more problematic "second" Futurism, scholars and curators could hope to place its achievements beyond the reproach of politics.

This narrative dovetailed with a post-war American foreign policy eager to exonerate Italy in order to create a partner in trade and treaties (particularly as a bulwark against the Communist East). The Museum of Modern Art's 1949 *Twentieth-Century Italian Art* inaugurated precisely the kind of "Boccioni-centric" and "painting-centric" historiography which would hold sway for many years. Futurism was presented here as a uniquely pictorial and sculptural phenomenon, divested of the activism integral to its development. MoMA's 1961 survey *Futurism* reprised the same parameters. Visitors to these exhibitions might well have concluded that the movement ended with World War I, and that its origins and consequences remained bound up exclusively with aesthetics.

This misprision has been fitfully and gradually corrected, beginning with the interventions of the art historian Enrico Crispolti in the 1960s and continuing through the scholarship of Claudia Salaris, Günter Berghaus, Giovanni Lista, Lucia Re, Jeffrey Schnapp, and others. Their studies reached beyond the

facile soundbites to which complex ideas were (and still are) too often reduced, restoring paradox and incongruity to rapports speciously presented as teleological and linear. Just as early Futurism betrayed proto-Fascist elements before the founding of Fascism itself, some of its later adherents refused the facile propaganda of state-imposed imperatives; if Futurist policy oscillated between opportunism and genuine support of Mussolini, it remained embattled against even more conservative factions in the cultural bureaucracy; while several left-wing artists attempted to merge Futurist strategies with revolutionary Marxism after World War I, the Italian Communist Party itself proved more aesthetically rigid than even the early Fascist regime.

In short, the received notion (particularly in Anglo-American circles) of a Futurist movement in immediate and absolute lockstep with Fascist reaction proves as untenable as it is enduring. What's more, the dismissal of Futurism as entirely isomorphic with Fascism formed the obverse of a related historical fallacy: namely, that Fascism had no genuine culture of which to speak. Both ideas lead us astray. The first, because it ignores what is distinct about each phenomenon; the second, because it disavows the appeal of Fascism to culture (and of culture to Fascism) in meeting modernity's numerous challenges and disenchantments.

This is not to say that Futurist solicitude or support of Mussolini's regime was illusory. On the contrary, following a brief schism after World War I, it remained steadfast in its endorsement for the entire *ventennio* (the Fascist "two decades"), at least publicly. Founding the Futurist Party in 1918 and standing in elections the next year alongside the fledgling Fascist Party, Marinetti would soon be forced to sacrifice his specifically political ambitions; the disastrous showing for their coalition on the November 1919 ballot prompted Mussolini to tack sharply right, shedding the more left-wing elements that had (alongside rabid nationalism)

united Futurism to early Fascism. Mussolini's overtures to big business and the Catholic Church alienated Marinetti for a few years—years during which he declared Futurism "Beyond Communism" and flirted again with left-wing politics.

After the March on Rome in 1922, Marinetti returned to the fold. Declaring a Fascist government the best means by which to realize Futurism's "minimal program," he reoriented its activities along chiefly aesthetic lines, deferring politics—at least in bureaucratic terms—to the new regime. If Mussolini's rule could be of service to Futurism, then so too, Marinetti insisted, did Futurism represent the prehistory and the destiny of Fascism itself.

His anthology *Futurismo e Fascismo* (1924) hastened to make that case. Opening with a reprint of the Founding and Manifesto of Futurism, it concluded with a speech on the Italian empire, dedicated—like the volume at large—to Mussolini. Marinetti's preface presented anarchic vitality as the obverse of despotic statecraft, attempting explicitly to affiliate the book's two eponymous phenomena:

> Futurism is a great anti-philosophical and anti-cultural movement of modernizing purifying innovating accelerating ideas intuitions instincts fists kicks and slaps, created on February 20, 1909 by a group of genius Italian poets and artists...
>
> We Futurists speak of Empire with the readiness and pleasure of fighting for it tomorrow. We wish to prepare Italy's youth to meet imperially [*sic*]—that is, rapaciously—the certain, perhaps imminent, and undoubtedly ferocious world conflagration to come. We speak of Empire because the moment has come for Italy to claim indispensable territories. Nearly all races fear war. But the bellicose temerity of our own race prevents any such fear—indeed, spurs us to desire war. The Futurist political program launched on October 11, 1913, which proposed a cynical astute and aggressive foreign policy, remains more relevant than ever.

Marinetti's intermittent lack of punctuation recalls the syntactical hurly-burly of his "Words-in-freedom." Yet the political substance of the text now falls neatly into line.

For his part, the Duce remained unmoved by Futurism. He was more partial to the classicizing modernism of the Italian *Novecento*—a group led by the influential critic Margherita Sarfatti which proved to be Futurism's greatest rival throughout the 1920s. Mussolini even spoke at the inaugural *Novecento* exhibition in 1923. Yet despite his affinity for that group's "plastic values"—and for Sarfatti herself, one of his lovers—he famously refused to name *any* movement the official representative of Fascist culture. "Far be it from me," Mussolini famously declared, "to encourage something that appears to resemble the art of the State."

Indeed, the state remained (fruitfully) ambivalent even about its own core values. As the theorist of Fascist political economy and political scientist Sergio Pannunzio put it in 1924, the same year as Marinetti's *Futurismo e Fascismo*:

> Fascism as an idea is undefinable. It is a fact that is still unfolding. As I see it, to fix its meaning today would be a contradiction in terms...Fascism, in its dual character, is revolutionary and conservative...We renew by preserving, we preserve by innovating. These are the two faces of fascism, apparently contradictory but fundamentally united in a single reality of thought, life, and history.

The regime's elusiveness on aesthetic matters—with the sole proviso that imagery should look "traditional and at the same time modern"—afforded a significant degree of leeway. It also increased exponentially the amount of work produced (whether tacitly or explicitly) in the service of the state, fomenting rivalry for attention and commissions. Well into the 1930s Mussolini hedged his bets as to what exact form or style a state art might take.

This was galling to Marinetti, who had helped pave the way for the regime, first as a Futurist and interventionist agitator, and then as a "Fascist of the First Hour." Conversely, that same vagueness offered Futurism the *promise* of continued relevance and patronage. And it was upon such a promise that Marinetti staked the movement's continuing efforts in the 1920s.

Those efforts demanded rethinking. The group was not only bereft now of Sant'Elia and Boccioni; Carlo Carrà had abandoned Futurism for the modernist classicism of "Metaphysical" painting, while Gino Severini pursued a self-confessedly neoclassical style in Paris. These trends were not as inimical to Futurism as its rhetoric would suggest. Indeed, many Futurists came to absorb aspects of the Europe-wide "return to order" after World War I—a recourse to more solid forms and consoling subject matter, often informed by classical proportions and motifs. This left them somewhat better prepared to respond to the cultural climate of the 1920s.

Even before his death, Boccioni had revisited the compact geometries of Paul Cézanne's paintings, famously anchored in "the sphere, the cone, and the cylinder." In a similar vein, numerous "second" Futurists came to pursue a figurative and linear precision consonant with aspects of *Novecento* painting. This younger generation of Futurist artists—including Fillia (Luigi Colombo), Nicolaj Diulgheroff, Antonio Marasco, Ivo Pannaggi, Mino Rosso, and others—further drew upon the volumetric styles of Enrico Prampolini, Fortunato Depero, and Giacomo Balla. Balla's painting *Numbers in Love* (1920) (Figure 28) exemplifies such tendencies, reconciling the flatness of abstraction to corpulence and perspectival recession, industrial luster to the rough-hewn robustness of craft. Depero's figures of the 1920s likewise appear at once decorative and scenographic, lending themselves to adaptation in a range of interrelated media.

The two artists' "Futurist Reconstruction of the Universe" manifesto (1915) also crucially anticipated elements of practical

28. Giacomo Balla, *Numbers in Love*, 1925, oil on canvas, 76,5 × 54 cm, Museum Ludwig Cologne.

construction and application, particularly as wed to notions of "Italian genius." The text's wide-ranging proposals became a touchstone for Futurist activity between the wars, while Balla's Roman studio helped renew the drive to synthesize different media. As painter, sculptor, architect, and set designer, Prampolini formed a further axis of continuity with early Futurism. Based in Rome but in dialogue with international avant-gardes from the De Stijl to Abstraction-Création, Prampolini's multifaceted practice helped to refresh Futurist influence abroad, especially in three-dimensional experiments.

The "constructive" ethos of interwar Futurism spurred the innovation of numerous set designs, for example, along with interior spaces from cafés to dance halls to theaters. Though hardly the "universe" pledged in Balla and Depero's manifesto, smaller "total environments" offered proleptic samples of larger integrations. Opened in 1922, Depero's Cabaret del Diavolo in Rome served as both a restaurant and venue for theatrical performances; its textiles, furniture, and lighting also aimed to create a unified aesthetic experience in its own right. Another such space inaugurated the same year was Antongiulio Bragaglia's Teatro degli Independenti (1922–31), the design of which involved the collective efforts of Balla, Depero, and Prampolini. Though Bragaglia's photographic theory and practice had been sidelined by Boccioni in the early 1910s, he proved vital to Futurism's second wave in Rome. The Casa d'Arte Bragaglia on the Via Condotti hosted exhibitions of Italian Dada and of Balla's latest paintings, in addition to some notable multi-media performances.

One such performance debuted there in June 1922: the *Futurist Mechanical Ballet* staged by former students of Balla, Ivo Pannaggi and Vinicio Paladini. Featuring two Russian actors outfitted respectively as the "Mechanized Man" and "The Proletarian," and incorporating the sounds of a live motor, the *Ballet* dramatized a contemporary industrial laborer's indecision between duty and pleasure. It also reflected the wider political affinities of Pannaggi

and Paladini, who this same year published the "Manifesto of Futurist Mechanical Art" (1922) (Figure 29). Born in Moscow to a Russian mother and Italian father, Paladini remained close to the radical left in both art and politics—an orientation shared by Pannaggi, nicknamed the "Muscovite from Le Marche" (the eastern Italian region of his origin). The pair not only found in the machine a "new impetus of revolt," but sought to channel that energy into an explicitly Marxist program. The drawings accompanying their manifesto—Pannaggi's stylized factory and Paladini's riveted automaton captioned *"Proletario"*—evince a plain kinship with both the Communist International and eastern avant-garde imagery.

Indeed, for a few years—coinciding with Marinetti's brief estrangement from Mussolini—some form of synergy between Futurism and leftist politics seemed possible, even probable. The Soviet commissar for culture, Anatoly Lunacharsky, deemed Marinetti "the one intellectual revolutionary in Italy," while Antonio Gramsci—the same year that he co-founded Italy's Communist Party—extensively praised Futurist cultural strategies. In an article titled "Marinetti the Revolutionary" (*Ordine Nuovo*, January 1921), Gramsci addressed the need to demolish "spiritual hierarchies, prejudices, idols and ossified traditions":

> The Futurists have carried out this task in the field of bourgeois culture. They have destroyed, destroyed, destroyed, without worrying if the new creations produced by their activity were on the whole superior to those destroyed. They have had confidence in themselves, in the impetuosity of their youthful energies. They have grasped sharply and clearly that our age, the age of big industry, of the large proletarian city and of intense and tumultuous life, was in need of new forms of art, philosophy, behaviour and language...In their field, the field of culture, the Futurists are revolutionaries. In this field it is likely to be a long time before the working classes will manage to do anything more creative than the Futurists have done.

PANNAGGI e PALADINI

Manifesto dell'arte meccanica futurista

Dal giorno in cui i primi manifesti futuristi furono lanciati, gli anni sono trascorsi pieni di lotte, sommersioni ed emersioni di vittorie ed amarezze di solitudine. Abbiamo lottato, alcuni

PALADINI : Proletario.

fattisi il nome ci hanno traditi, altri sono morti (**Boccioni** è il grande, il ricordo luminoso e caldo), nuove attività si sono svegliate, **nuove necessità si sono sentite.**

Ora ci attanaglia impellente il bisogno di ... i degli ultimi avanzi di vecchia letteratura ... mbolismo, decadentismo, per attingere spunti di rivolta da ciò che è la nostra vita. Dalle MACCHINE.

Ciò che **Boccioni** ed altri avevano intuito (la modernolatria) ci avvince con le nuove forme imposte dalla **meccanica moderna**.

Oggi è la MACCHINA che distingue la no" stra epoca. **Pulegge e volani, bulloni e ciminiere, tutto l'acciaio pulito ed il grasso odorante (profumo di ozono delle centrali).**

Ecco dove ci sentiamo irresistibilmente attirati. Non più nudi, paesaggi figure, simbolismi per quanto futuristi, ma l'ansare delle **locomotive**, l'urlare delle **sirene, le ruote dentate,** i pignoni, e tutto quel **senso meccanico** NETTO DECISO che è l'atmosfera della nostra sensibilità.

Gl'**ingranaggi** purificano i nostri occhi dalla nebbia e dall'indeciso, tutto è più **tagliente, deciso, aristocratico, distinto.** Sentiamo meccanicamente e ci sentiamo costruiti in acciaio, anche noi macchine, anche noi meccanizzati dall'atmosfera. La bellezza dei bei carri da trasporto ed il **godimento tipografico** delle iscrizioni reclamistiche solide e voluminose, *il trenolare sconquassato di un* CAMION, l'architettura fantastica di una grue, gli acciai lucidi e freddi.

Ed è questa la nuova necessità, ed il principio della nuova estetica.

Poi andremo più avanti.

CONTRO TUTTI!

PANNAGGI: Composizione meccanica.

29. Vinicio Paladini and Ivo Pannaggi, "Manifesto of Futurist Mechanical Art," 1922.

Before throwing in his lot with Mussolini after 1924, Marinetti pursued rapports with Italy's Proletkult. He even related to Gramsci his excitement that factory workers in Turin responded to Futurist art more astutely than Italy's middle classes.

The alliance nevertheless proved short-lived. It succumbed to pressure from both sides of the political spectrum. On the one hand, conservative Italian Communists disapproved of modernist strategies; on the other, Fascist ideologues rejected even the faintest whiff of Bolshevism. Despite attracting a cadre of younger, dynamic artists to Futurism like Bruno Munari and Aligi Sassu, Pannaggi and Paladini's Mechanical Art formed a casualty of such divisions. Prampolini summarily authored a new version of the manifesto. Stripping it of materialist and Marxist allusions, he stressed instead the metaphysical and "spiritual" dimensions of Futurist mechanization.

The Turin-based painter and poet Fillia underwent a similar transition. His philo-Communist lyricisms of the early 1920s homed in on the factory floor as a site of mechanical rapture and revolutionary fraternity. At the heart of a poem like Fillia's "The Factory Interior" (1925)—wherein the "negation of the self" gives way to paroxysms of gratifying automation—lies the reality of Turin's industrial and syndicalist culture. The text circulated in Futurist publications even after the declaration of Mussolini's dictatorship. By the decade's end, however, Fillia was painting celestial elements in works like *Spirit of the Aviator* (1929) and *Divinity of Aerial Life* (1933–34), influenced by Prampolini both formally and ideologically.

If these "spiritual constructions" exemplified the new genre of Aeropainting, they also reflected the overtures to Christian theology evinced in Fillia's own texts "Sacred Mechanical Futurist Art" (1926) and "Futurist Spirituality" (1929). Mussolini's concordat with the Vatican in 1929 underscored such an unlikely rapprochement. More than any explicit theological doctrine,

however, Futurism's increasingly metaphysical imagery reflected the Fascist "revolution of the spirit"—an ideological axiom set against the Communist "revolution of matter." To wit, "sacred" Futurist imagery enjoyed support not only from some Catholic circles but also the Fascist cultural syndicates.

Fillia and his Futurist peers tried to shore up that support with other initiatives. Their success was intermittent. The 1934 manifesto of "Plastica Murale" (roughly translated as "three-dimensional murals") insisted that architecture no longer be distinct from its decorations; it would instead form a multimedia "synthesis of modernity" bearing a recognizable "subject." That subject typically consisted of Fascist symbols like the fasces or the Roman salute or, more often than not, the Duce himself. Depero's proposals for large-scale murals—to name just one of dozens from the time—featured an airplane engine titled "The Duce's Heart." The mounting cult of Mussolini comprised not only the metaphorical import of his body ("Italy possesses one head: that of the Duce!" ran one refrain), but also its obsessively literal iteration. His likeness appeared in every possible context, every imaginable substance, style, and guise—from murals to table lamps to shovels, from the monumental to the portable.

Renato Bertelli's *Continuous Profile of the Duce* epitomized that versatility (Figure 30). As a younger recruit to Futurism in the early 1930s, Bertelli joined Antonio Marasco's "dissident" group in Florence—the so-called Futuristi di Iniziative, who circumvented Marinetti's peremptory authority while remaining fervent in their devotion to Mussolini. Though chiefly produced as a medium-sized patinated ceramic, Bertelli's sculpture appeared in numerous materials and sizes. Its reproducibility and mobility facilitated purchase by town halls and other institutions, and the artist even applied (successfully) for a patent. Despite the *Profile*'s actual fixity, it appears to spin ceaselessly, reproducing the Duce's profile from every angle and lending his omniscience palpable form. If on the one hand the sculpture recalls ceramic electric insulators and

30. Renato Bertelli, *Continuous Profile of Mussolini, or Continuous Profile—Head of Mussolini*, 1933, bronze, 42 × 22cm, Fondazione Massimo e Sonia Cirulli, Bologna.

explosives, it also conjures up the Roman god Janus. It thus reconciles an illusion of unrelenting movement to a sense of eternal myth: precisely the "permanent revolution" which the regime actively propagandized at the time.

Permanence of any sort had formed Futurism's *bête noire*. Marinetti's induction into the Fascist *Accademia d'Italia* in 1929 signaled an uneasy pact with patrimony by the decade's end. The former anti-academic firebrand even penned some half-hearted homages to pre-modern authors like Dante and Ariosto, declaring

113

them Futurists *avant-la-lettre*. Far more crucial to the movement's continuing ambition, however, was its *own* past: specifically the work of Boccioni and Sant'Elia, championed as Fascist martyrs despite their deaths before Fascism's founding.

Numerous artists laid claim to the two artists' respective legacies, even while churning out fundamentally second-rate work. Virgilio Marchi published a "Manifesto of Futurist Architecture" in 1920, yet produced little more than a series of whimsical images, finding far better success as a set designer for the cinema. Dubbed by his peers the successor to Boccioni's sculptural feats, Mino Rosso proved essentially an epigone of Futurist and Cubist innovators in three dimensions. To be sure, Rosso and other Turin-based colleagues—Fillia, Diulgheroff, Pippo Oriani—invigorated Futurist activity across the industrial north, just as other "second" Futurists spearheaded local groups as far as the remote, rural south. If the movement's aesthetic output proved sporadic in quality, its membership remained comparatively robust.

Futurism's increasing defensiveness against conservative cultural factions mirrored wider polemics over what kind of architecture should represent the regime. Here too, traditionalists increasingly outflanked modernists. Rationalist architects like Alberto Sartoris—a Futurist affiliate and founding member of the Congrès Internationaux d'Architecture Moderne (CIAM)—found their position ever more out of favor. A case in point was the 1932 Exhibition of the Fascist Revolution, held at Rome's Palazzo degli Espozioni to mark 10 years of Mussolini's rule. The exhibition's façade and a few rooms were given over to rationalist architects and Futurist artists; Gerardo Dottori's room celebrating "The Regime's Achievements in Agriculture and Transportation," for example, featured naval and aerial imagery in a modernist key. Yet the most prominent rooms reflected the archaizing motifs increasingly vital to the regime's millennial pretensions.

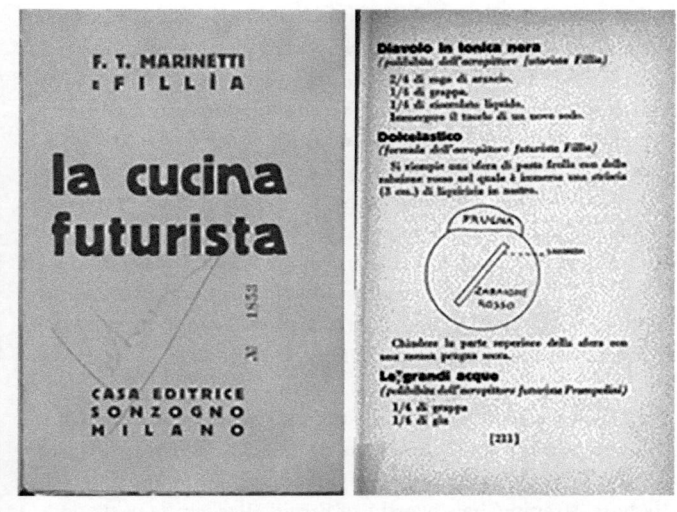

31. F. T. Marinetti and Fillia (Luigi Colombo), *The Futurist Cookbook*, Casa Editrice Sonzogno, 1932.

Futurism's interdisciplinarity meant that it could pursue varied—sometimes desperate—strategies in a quest for relevance. Perhaps the best known of these later enterprises is the *Futurist Cookbook* (1932) edited by Marinetti and Fillia (Figure 31). Along with an injunction against pasta (to the degree that it supposedly made Italians lethargic), the book presented outlandish recipes by a number of Futurist artists and critics. Dishes bear appropriately synthetic names like *Tuttoriso* ("All-rice" with salad, wine, and beer), *Aerovictuals* ("tactile, with noises and smells"), and *Sveglistomaco* ("Stomach-stirrer," with pineapple and sardines). The authors also set out to liberate culinary language itself from foreign influence. The volume thus concludes with a dictionary of Futurist food, replacing loan words like "cocktail" with "*polibibita*" ("poly-beverage") and "picnic" with "*pranzoalsole*" ("lunch-in-the-sun").

As evidenced by a recipe for a "Squadrist Snack" and a "Marinetti-Bomb" dessert, Futurist cuisine was more than merely playful. Couched in eccentric concoctions, its violent nationalism was aimed at "true patriots, that is, Fascists who throb with an authentic passion for Italy and an indefatigable Italian pride." Marinetti's rejection of pasta was not a gratuitous campaign against indolence, nor were the book's hypernationalist recipes mere jabs at "philo-foreign" cuisine. They sought to help circumvent Italy's dependence on foreign wheat. Mussolini's "Battle for Grain"—and Fascism's quest for economic sovereignty more broadly—had begun in the 1920s, well before international sanctions would make such autonomy unavoidable.

Published the same year as the *Futurist Cookbook*, Marinetti's "Futurist Manifesto of the Italian Hat" (1932) likewise proposed the use of synthetic and autarkic materials in fashioning "radiotelegraphic" hats, worthy of Fascist Blackshirts past and future. Mixed with reactionary cant, the frivolity of such proposals left more radical Futurists wondering where the movement was headed. Segments of a younger generation found themselves increasingly alienated as Marinetti and his closest associates drifted toward buffoonery.

Others instead affirmed the absolute seriousness of the Futurist mission, as well as its singular purchase on Fascist cultural representation. "As an alliance of artists who paved the way for and joined forces with the Fascist revolution," affirmed Fillia in 1930, "the Futurists alone possess the right to represent an Art of the State." That state nevertheless continued to have it both ways. Fascist culture telegraphed youth, energy, and dynamism, applying a revolutionary veneer to the very bureaucracy which marginalized Futurist artists from lucrative commissions. Many rank-and-file Futurists proved fundamentally apolitical, or else paid lip service to Fascism as a means of securing work. Yet the movement's most prominent voices remained unwavering in their public support.

For his part, Marinetti's relentless output rendered his person essentially interchangeable with Futurism *tout court*—an identification which endures. His leadership did not go entirely uncontested over the years, however. Prominent Florentine contributors revolted early on against what they dismissed as "Marinettism," laying claim to their own interpretation of Futurism. The Neapolitan "Circumvisionists" attempted to secede outright in 1927, while the painter Antonio Marasco launched a group of "Independent Futurists" in 1933. None of these events loosened Marinetti's tentacular grasp on Italian modernism, however. To his credit, furthermore, he shirked the kind of retaliatory purges undertaken by subsequent avant-garde ringleaders like André Breton. "Futurism," Marinetti remarked at one point, "is not one school, but a group of independent artists. I'm not their master. I am a motor." By whatever name, he remained the movement's de facto leader for more than three decades, two world wars, and an abiding (if embattled) service to Mussolini's regime.

Chapter 9
Empire, race, war (again)

Futurism raised eyebrows abroad in the 1930s for its seemingly obsequious deference to Fascist doctrine. Yet that same international presence stoked accusations back home of an objectionable anti-Italianness—a charge levelled at Marinetti's movement with increasing frequency by more reactionary cultural factions. The Futurist leader never relented in his pursuits. With his appointment to the Fascist *Reale Accademia* in 1929, however, he was obliged to downplay the radical elements of the movement's past—whether its early anarchist sympathies or divergences from the Fascist political platforms of 1919–21. Marinetti's anti-clerical frustrations, moreover, could henceforth be voiced strictly in private.

In exchange, Futurism enjoyed a modicum of institutional clout. Marinetti facilitated the state's purchase of Futurist works from the Venice Biennale, and managed even to sideline Margherita Sarfatti's *Novecento* group as a serious rival by the late 1920s. His still frequent trips abroad served as de facto propaganda campaigns for the regime throughout the 1930s, from Budapest to Buenos Aires. Regular debriefings with the Duce ensured as much. These efforts still came hard up against the regime's rigid bureaucratization on the one hand, and, on the other, Fascism's intensifying reliance on the ready-made identities of *Italianità*

and *Romanità*—the very traditions against which Futurism had long inveighed.

The Fascist reappropriation of imperial history began in earnest with the founding of the Institute for Roman Studies in 1925, followed by the adoption of the lictors' fasces as the state's official emblem the next year. The restyling of Roman symbols and rituals multiplied over the next decade, culminating in the declaration of a "New Italian Empire" after the conquest of Ethiopia in 1936. Rome's historical dominion could be seen to inform even the most technologically advanced projects of the 1930s. The construction of sporting arenas and highways, the draining of historical wetlands, and, of course, the vicious colonizing projects in Libya and the Horn of Africa: these all revived ancient imperial feats as much as they broke new ground.

The construction *and* destruction entailed in the paving of Rome's Imperial Way—inaugurated in 1932—epitomized the productive ambivalence of such undertakings. If the new avenue highlighted the Eternal City's archaeological wonders, it also sacrificed a large swathe of those same remains in the name of modern traffic circulation. Fascist urbanism thus drew as much upon a bulldozing ahistoricism as it did upon the recuperation of antiquity. What remained forward-looking in Fascism's approach to modernity—and there remained a good deal—thus provided Futurism with some lingering, if dwindling, pretensions to relevance as the 1930s wore on.

After all, aggressive nationalism and militarism had formed its core ethos well before Fascism's rise. Cultural historians still disagree as to just how much influence Futurism managed to wield into the 1930s. While Marla Stone describes Futurism's place in cultural echelons as a "prized" one, Günter Berghaus characterizes the regime's attitude as "predominantly hostile." What is certain is that, as Mussolini gradually readied Italy for

imperialist expansion and warfare, the Futurists offered their services at every turn. Already in 1929 Marinetti took to the *Gazetta del popolo* to announce that a new world conflagration was imminent. His article "The Future War" called for the Italian populace to familiarize itself with the inevitability of aeronautical and chemical combat, to resolve the questions of war "futuristically." "Though Fascist Italy desires peace," he added unconvincingly, "it prepares itself intrepidly for the necessity [of future war]."

Several artists launched the "Manifesto of Aeropainting" (1929) this same year. Futurist stalwarts Giacomo Balla, Fortunato Depero, and Enrico Prampolini added their signatures alongside "second wave" painters like Gerardo Dottori, Tato, and Fillia (Luigi Colombo). Aeropainters sought not simply to *represent* various kinds of aircraft, but to assimilate the "shifting perspectives of flight" to the very mode of representation.

> We Futurists declare that the principle of aerial perspectives and consequently the principle of Aeropainting is an incessant and graduated multiplication of forms and colors...By an absolute freedom of imagination and an obsessive desire to embrace dynamic multiplicity with an indispensable synthesis, it captures the immense visionary and sensual drama of flight.

In theory, such strategies would reproduce the phenomenological essence of flying. In practice, their results proved decidedly mixed. A few artists like Marisa Mori, Osvaldo Peruzzi, and Benedetta (Figure 21) produced compelling fisheye panoramas and rippling, vertiginous abstractions. The lion's share of aeropainting, however, careened from the bombastic to the prettified to the impossibly kitsch. Far more striking than the quality of aeropainting was the quantity produced. Its examples quickly burgeoned into related manifestations (and accompanying manifestos) of aeropoetry, aerosculpture, aerodance, aeromusic, aeroceramics, even aeroperfume. These revived the Futurist project of a totalizing synthesis of life and art.

Aeroaesthetics also came to stand in for Futurism at large, precisely at a time when airpower proved both a military flashpoint *and* a focus of popular culture. Whether through mass intercontinental expeditions, regional airfields, or widespread print media, "aeromania" permeated every aspect of Italian society. And of all the groups vying for the regime's favor, Futurism was unrivaled in modern evocations of this most modern phenomenon. Reminding the movement's anti-modernist detractors of this fact, Fillia boasted that Futurism alone had grasped the implications of a "world modified by the machine." His volume *Fascist Art: Elements for Artistic Battle* had already railed in the 1920s against

> the residue of an old mentality, in contrast with the young, fast, innovative, optimistic, and mechanical spirit of Italian Fascism, which carried out its formidable work, pursuing the objectives of expansion, competition, and victories which are typically Futurist.

Aerial perspectives could transform even ancient monuments like the Verona Arena or the Arch of Titus into totems of Futurist turbulence. Filippo Masoero's aerophotograph *Descending over Saint Peter's* (1927–37) renders the cathedral's dome a dynamic vector of energy rather than a symbol of Renaissance gravitas. Or consider Alfredo Ambrosi's *Aeroportrait of Mussolini* (1930) (Figure 32). The subject's looming, three-quarter profile appears interchangeable with the urban fabric of the Imperial Way, which links the Colosseum to Piazza Venezia where an (ostensibly adoring) crowd gathers beneath the balcony of Mussolini's office. The Duce's image as Italy's *primo pilota* ("first pilot") afforded all manner of predictable metaphors. In exploiting them, Futurist artists helped cast the reprisal of empire—its "expansion, competition, and victories," in Fillia's terms—as a fundamentally progressive enterprise.

Apace with an increasingly belligerent foreign policy, the Fascist policy of autarky (economic self-sufficiency) gathered momentum

32. Alfredo Ambrosi, *Aeroportrait of Mussolini as Pilot*, 1930, oil on canvas, Aeronautico Caproni Museum, Taliedo.

in the 1930s: an industrial, mineralogical, and alimentary autonomy which laid the groundwork for imperialist expansion. Even seemingly light-hearted Futurist initiatives promoted the use of autochthonous materials, as did the frequent use of aluminum in aerosculpture. Illustrated by Bruno Munari,

Marinetti's free-verse *Poem of the Milk Dress* (1937) pays Futurist homage to the synthesis of the fabric Lanitol from whey casein. Aesthetic evocations of autarkic materials gained fresh currency in the wake of Italy's incursions into Abyssinia and resulting international sanctions by the League of Nations, after which time synthetics became unavoidable parts of everyday life.

Yet the Futurists had launched paeans to these substances in advance of imperial conquest. The aeropoet Ignazio Scurto and aerosculptor Renato di Bosso co-authored the "Manifesto of the Italian Necktie" (1933), proposing a metallic cravat which would lend its wearer the "aviational inflection" of an airplane wing. They opposed this to the "limp" fabric of regular ties, declared alien to Italian virility and speed. The manifesto's signatories noted the zeal with which "both the people and intellectuals have greeted our invention." The text's reach was surely limited. Yet, like Balla's proposal of the "Anti-neutral suit" on the eve of Italian intervention into World War I, the Futurist necktie aimed both to incorporate national pride into everyday life and to ready the populace for the idea of war by way of culture.

In the same vein, the *Futurist Cookbook* not only imagined "aerobanquets" and "aero-recipes," but promoted the consumption of colonial commodities. Fillia's *Italian Synthesis Luncheon* specified that its mullet be stuffed with "Colonial Instinct" (dates, bananas, carob); Mino Rosso's "aerosculptural" *Network in the Sky* featured tamarind pulp and pistachios; the *Libyan Airplane* by the pilot and aeropainter Fedele Azari included banana, honey, and dates. However waggishly, such ideas helped normalize Italy's "natural" extension into Africa and the extraction of its raw materials—an extension and extraction facilitated by aerial domination.

Futurist participation at the Fascist colonialist exhibitions of 1931 (Tripoli, Rome) and 1934 (Naples) promoted this domination even more explicitly. Introducing the aeropaintings on display,

Marinetti declared to readers that "[t]he African (and simply colonial) atmospheres are there for exploration…subjugate by Italian means [*dominare italianamente*] the particular character of other races, colonizing them through art." The following year, the aeropainter (and Marinetti's wife) Benedetta launched a "Futurist Recruitment Project for the Next War," promising that a "future aerial-chemical" conflict would offer older citizens a "useful death on the battlefield instead of a sad death in their beds."

That future conflict arrived in short order. Almost on cue, it entailed aerial and chemical subjugation, including the use of mustard gas on non-combatants. Italian troops invaded Ethiopia from neighboring Eritrea in October, 1935—a war of aggression against a sovereign nation. The conquest sought both to avenge the humiliating defeat of the first Italo-Ethiopian War (1895–96), and to carve out a swathe of Africa worthy of an imperial past and bright new future. Swift sanctions did nothing to curb this assault upon what the regime called "Italian East Africa," encompassing current-day Somalia and Eritrea as well.

At 58 years old, Marinetti had lost none of his dedication to war as "the world's only hygiene." Once again, his commitment proved to be more than rhetorical. Receiving special dispensation from the Duce to enlist as a volunteer soldier in the "October 28" Division (named for a key date in Fascist history), he served until April 1936. Marinetti's experience at the Battle of Passo Uarieu (Worsege) served as the touchstone for the "African Poem of the 'October 28' Division" (1937)—a reprisal of his early "simultaneous" poetics from the Italo-Turkish War (1911) and the Balkan Wars (1912–13). There is nothing innovative about the verse's warmed-over *words-in-freedom*, however, which describe the Duce hailing Italy's new empire from his office balcony in an act of manifest destiny. Marinetti's earliest Futurist crusades—particularly his "African" novel *Mafarka the Futurist*—had come full circle, but in terms of crude imperialist exploits rather than aesthetic advancement.

Marinetti's labors extended now from the battlefield, to diplomatic missions seeking French political support, to recruiting further Futurists for imperial war. Nearly 100 of the latter enlisted. Some served as soldiers, some as painters and photographers, others still in multiple guises. The aeropainters Mario Menin, Alfredo Ambrosi, and Renato Di Bosso produced images of the Fascist fleet soaring over African landscapes evacuated of human presence—except, that is, of disembodied Italian pilots, their gazes "multiplied" by aerial surveying power. When "natives" do appear—as in Di Bosso's wooden relief, blithely titled *African Adventure* (1936)—they appear as anonymous, interchangeable, and semi-abstracted forms, subject to controlling gaze or even touch.

Many aero-artists—and indeed many Futurists in general—were fundamentally apolitical. The intentions informing their respective works ranged from the formalist, to the ideological, to the opportunistic, to various convergences thereof. Some art historians argue for the aesthetic value of aeroaesthetics independent of Fascist warmongering; as further evidence of such autonomy, they point to the regime's refusal to champion Futurism as its official aesthetic. Yet if Mussolini tempered his embrace of the movement, the latter's expositors never relented in their public support of the government. If much aero-imagery exalted ideas of a transcendent "cosmic" realm, an equal amount glorified the contingencies of mechanized violence and its historical significance for Fascist Italy.

Indeed, a good deal of aeroaesthetics proved aggressive and racist from the start. Tullio Crali's paintings from the early 1930s celebrate "bombardments" and "battlegrounds," while one "Giorno dell'Ala" ("Day of the Wing") celebration held in Rome in June 1930—and filmed by the Futurist Masoero—featured an ersatz "African village" which Fascist squadrons demolished with machine gun fire. In short, the propagandistic potency of aeroaesthetics is undeniable, especially as it intersected with

campaigns of autarky, imperialism, and war. Its visual and verbal imagery not only heralded the aerial violence of empire and combat; it accustomed the public to their "sublimity."

By 1938, any lingering lyrical subtleties had given way to overt propaganda. A gallery of "Futurist Aeropainters of Africa and Spain" featured in that year's Venice Biennale at Marinetti's behest. Italy's aerial terror campaigns on behalf of General Franco in the Spanish Civil War joined the Ethiopian invasion as worthy of Futurist-Fascist exaltation. The Biennale's conclusion coincided with the regime's declaration of Racial Laws, preceded in July by the notorious Fascist "Manifesto of Race." Among other punishing measures, the new laws severely restricted the civil rights of the nation's Jews and forbade intermarriage among Italians, Italian Jews (no longer considered Italian), and Africans. The Racial Laws sealed Italy's proximity to Nazi Germany in advance of the Hitler–Mussolini Pact of Steel the following year.

After inviting the Futurists to exhibit in Berlin and Hamburg in 1934, Nazi officials had rejected aeropainting on the grounds that its modernist imagery smacked of "Bolshevism." Goebbels's Ministry of Propaganda distanced itself from the style, despite Marinetti and Ruggero Vasari's efforts to the contrary. Hitler's denunciation of the "Cubist–Dadaist cult of primitivism" might otherwise have spared the Futurist cult of hypermodernist machinery, especially in light of the philo-technologism which accompanied the *volkish* reaction of Nazism itself. Yet not even Marinetti's virulent nationalism could rescue Futurism from charges of "cosmopolitan" (i.e. Jewish and Bolshevik) sympathies back in Italy. Modernist artists and authors increasingly risked accusations of decadence, heresy, even anti-Fascist "destruction." Emilio Settimelli—co-author of the "Manifesto of Futurist Cinema" (1916), an independent Futurist since the early1920s, and volunteer in the Ethiopian campaign—ran afoul of the regime for criticizing its mountingly reactionary politics. Ejected from the Fascist Party in 1939, he was sentenced to internal exile.

If Settimelli had dogged Marinetti from the (relative) left, the leader's right flank remained exposed to hardline Fascist Party officials like Roberto Farinacci. A hefty secret police file on Marinetti—who was frequently tailed and his private conversations recorded—attests to a strained relationship with the regime, notwithstanding his tireless exertions on its behalf. Even a former Futurist like Ardengo Soffici—a dyed-in-the-wool cultural conservative and supporter of the Racial Laws—had long since advocated (since 1926!) for stricter measures against what he deemed culturally "barbarian, anti-Italian, liberal, Judaic, Masonic, democratic—in a word, anti-fascist" elements. Along with fellow Futurist and Fascist enthusiast Mino Somenzi— himself of Jewish descent—Marinetti decried Fascist anti-Semitism, particularly as it bore upon the Nazi persecution of modern artists.

Marinetti's responses on the whole were inconsistent and ham-fisted, however. He appealed to the very racist rhetoric he sought to parry. It was true that Futurism had inspired foreign and left-oriented tendencies, he insisted, but it shared nothing of these groups' dangerous political ideologies. Nor, Marinetti claimed, did the movement harbor any Jews, despite the presence of Somenzi himself—a participant in the March on Rome, a signatory of the Aeropainting manifesto, and the founder of the journal *Artecrazia* (shut down in 1938 by the regime for its "modernist" leanings). Marinetti initially voiced displeasure with the Axis partnership. He likewise played a key role in opposing an Italian-style "Degenerate Art" exhibition, which Fascist reactionaries like Farinacci hoped to use to intimidate avant-garde artists, in emulation of the Nazi original.

Italy's declaration of war on Britain and France in June 1940 saw Marinetti fall neatly into line, however. He passively accepted Fascism's Racial Laws. He also actively—in a 1942 text titled "The Italian Army"—decried "democracy, communism, Judaism" as "dusty obsolescences [*passatismi*] by turns depressing and

traitorous." Futurist exhibitions and recitations became explicitly dedicated to the war effort. The 1942 show "Six Futurist Aeropainters of War" featured paintings like *African Aeromachinegunner* (1942). Such an image makes plain the violence implicit in Futurism's aerial views, whether or not they focus, as they do here, on a generically North African topography.

For the last time, Marinetti set about recruiting Futurists for military service. And, once again, he volunteered himself. In spite of his 66 years, he joined the Russian campaign and served briefly on the eastern front in the summer and fall of 1942. The experience left him ill and exhausted, but by no means chastened. Upon his return to Italy he joined the Italian Social Republic, better known as the Republic of Salò: the rump Fascist state propped up by Nazi forces in the country's northern half after September 1943. Viciously anti-Semitic and totalitarian, the Salò government formed a mere puppet state. Yet it also claimed to revive the early *dicianovista* ("1919") ideals of Fascist republicanism, of which Marinetti had been a fierce promoter.

The doomed Salò project would collapse in short order, though Marinetti did not live through its last gasps. He succumbed to a heart attack in his Belagio hotel room on December 2, 1944. For his state funeral in Milan three days later, the procession paused in Piazza San Sepolcro—the site of Fascism's founding assembly in 1919, which Marinetti had himself attended.

A great deal differentiated Fascist rule from the early Fascist movement. Yet Marinetti had recognized even in Mussolini's regime the potential realization of Futurism's "minimal program"—that is, the implementation of its basic imperatives in and by an official polity. Bureaucratic proceduralism, Marinetti believed, would eventually give way to the intoxicating élan of art.

As late as 1938—the year of Italy's Racial Laws—the critic Francesco Bruno insisted in the journal *Mediterraneo Futurista* upon the

involuntary [*sic*!] convergence between Futurist theories and the most significant movements of contemporary thought: from Nietzsche to Bergson. [Gabriele] D'Annunzio would make of man a demiurge; Futurism goes further still, approaching life as élan and creative evolution. Whoever lives, works; whoever acts, creates. Because life is activity, it is poetry, and the artist is a man forever tensed in acts of will and creative intuition.

Emblazoned across the journal's masthead reads one of many combative dictums by the greatest "Futurist artist," Mussolini: "If necessary we shall fight; if we fight we shall win."

But did the regime's attempts at cultural totality indeed consummate Futurism's creative and activist ambition? Or did it travesty them? By what criteria might we even measure an answer?

One potentially instructive benchmark lies in the "Futurist Political Program," signed by Marinetti and the artists Boccioni, Carrà, and Russolo, way back in October 1913.

> Italy, absolute and sovereign. The word ITALY must predominate over the word
>
> > LIBERTY.
>
> All freedoms must prevail other than those of being cowardly, pacifist, or anti-Italian. A bigger fleet and a bigger army; a people proud to be Italian, in favor of war, the sole hygiene of the world, and of an Italy that is intensely agrarian, industrialized, and noncommercialized.
>
> Economic protection and patriotic education for the proletariat.
>
> A foreign policy that is self-interested, shrewd, and aggressive— colonial expansion—free trade.
>
> Irredentism—Pan-Italianism—the supremacy of Italy.
>
> Anticlericalism and antisocialism . . .

Setting aside anticlericalism and the (actual) emancipation of the proletariat, we find here some kernels of Fascist irredentism, nationalism, imperialism, and militarism. Other points from the larger program—from a cult of sport to the abolition of foreign-owned industry—would likewise find realization in Mussolini's regime.

To be sure, that same administration ignored Futurism's cultural injunctions against museums and the cult of classicism. Marinetti himself was made over into the very "gouty Academic" he had denounced. Fascism styled itself as a "permanent revolution" well into the late 1930s. The rhetoric of Futurist agitation upon which it drew was, by those years, mostly a nostalgic memory—the very kind that Marinetti had set his movement against. Such was the price he was willing to pay for a deferred Futurist future. His Nietzschean individualism had always chafed against the necessities of a mass movement. Still, his unreconstructed sense of hierarchy found some reflection in the rigidly vertical structure of Fascist nationalism. Marinetti's collaboration was ultimately staked upon equal parts expediency, fanaticism, and a genuine hope that he could bend Fascist officialdom to Futurist ends.

Thus, a movement which had championed "individualists of every land, whether libertarians or anarchists," came to hail a very different kind of "liberty." Indeed, Mussolini made plain in his *Doctrine of Fascism* (1932) that "the rights of the State express the real essence of the individual." Right up to the regime's disastrous end, Marinetti believed that his efforts could inflect Fascist totality with the multiple singularities of expressive freedom. Even more improbably, he clung to the notion that Fascism's social utopia might one day realize the exhilaration of Futurist poetry rather than the repressive prose of tyranny. How wrong he was proven to be in the end.

Chapter 10
The futures of Futurism

> "Put your trust in Progress, which is always right even when it is
> wrong, because it is movement, life, struggle, hope...Progress
> is always right."

What must we make, in the end, of Marinetti's blind Futurist faith,
his belief in change for change's sake? Might progress bear some
transcendental righteousness of its own? Does the vitality of
aesthetic "struggle" ever absolve such advancements of their moral
failings?

That these lines above come from an essay titled "Electric War:
The Birth of a Futurist Aesthetic" (1911) speaks volumes by way of
an answer. Futurism's social utopia comprised profoundly
dystopian elements from the start. It preferred violence to the
stale certitude of posterity. Its relentless will to progress entailed
the movement's own self-destruction; its abrupt end with World
War II proved a kind of fait accompli. Whatever the ambitions of
its early adherents, Futurism's ideological compromise with
Fascism remains as indisputable as it is irreversible.

We must not rush to throw out the avant-garde baby with its
noxious bathwater, however, for the very notion that modern
literary and artistic initiatives might effect actual political change
owes a great deal to Futurism. To be sure, so too does the spectacle

of populist politics as an artistic (and often misogynist and xenophobic) performance—one which often masks a thinly veiled contempt for the very public played to. Yet the Futurist contribution to 20th- and 21st-century culture is hardly reducible to proto- or pro-fascist nationalism.

The movement influenced in equal measure 1960s and 1970s countercultural expression in Europe and America, the rise of mid-century Italian design, and neo-avant-garde experiments in performance and concrete poetry—to name only some of its aesthetic resonances. Futurism's continued relevance to a range of phenomena derives from a stubbornly paradoxical set of imperatives: cultural insurgency/undemocratic hierarchy; a cult of elitist genius/appeals to mass society and mass communication; technological advance/anarchic irrationalism; machinic objectivity/individual expressivity; scientific innovation/ anti-Enlightenment intuition. Telling in this sense is Futurism's impact upon both the most nihilistic and conceptual of modernist tendencies (Dada) and the most benignly decorative (Art Deco).

Already in the early 20th century, critics and a wider public alike used the term "futurist" to denote modern art in general. Apart from its specifically Italian application, this lower-case iteration served as a placeholder for avant-garde animus writ large. The word still abounds in common parlance. I have found it recently applied to everything from Joni Mitchell's auteurist songwriting of the 1980s, to the cinema of Ridley Scott, to Estée Lauder lipstick, to the philosophy of Gilles Deleuze, to nifty silver rings sold on Etsy. Even the word-processing application used to write this text (arguably descended in part, like the rest of Apple products, from modernist design) proposes the word "futurist" as a synonym for "seer," "prophet," "visionary." Notwithstanding ongoing arguments about the end of history (to say nothing of the end of modernism), disparate political, aesthetic, sociological, and economic concepts still find in futurity—or at least in its suffix form—the cachet of innovation.

A vast semantic afterlife suggests as much, including Ecofuturism, Agro-futurism, technofuturism, econofuturism, "reproductive futurism," Neofuturist architecture, queer futurism, Neofuturist theater, etc. The still more ample aegis of Futurism (or "Futurology") today comprises the interdisciplinary study and promotion of social and technological advancement—not entirely dissimilar from the historical movement's original impetus, at least in broad strokes. Even the term's inflection by multiple tense constructions (i.e. "retrofuturism," the study of past evocations of cultural advancement) reveals the abiding attraction of a basic pretext: a resistance to mere contemporaneity, by phenomena imagined but not yet arrived.

We might recall here an observation by the art historian Maurizio Calvesi. The notion that Futurism began and ended with an exaltation of machines, he argued, is tantamount to claiming that a Pop sensibility in art exhausted itself with the proliferation of mass media. As Calvesi rightly remarks, Futurism's innovations lay not in any superficial worship of technological objects, but in the attempted transformation of perceptive faculties—a transformation incorporating into its very modes the experience of technology. What Marinetti called "numerical sensibility" would replace all too human emotions, which the Futurist painters projected onto modern machines:

> Our renewed consciousness does not permit us to look upon man as the center of universal life. The suffering of a man is of the same interest to us as the suffering of an electric lamp, which can feel pain, suffer tremors, and shriek with the most heartrending expressions of torment.

The ethical implications of such inversions take on new weight with the proliferation of the World Wide Web and Artificial Intelligence. The internet's global spread, its software applications, and design apparatuses such as the smart phone realize a range of Futurist ideas. A platform like Twitter seems to

have sprung almost directly from Marinetti's call for "synthetic brevity": "Quick," he insisted, "tell me the whole story in two words." Or consider instead Fortunato Depero's 1916 design for "Plastic-Noise Gloves," the sensor-nodes of which were envisioned to connect the wearer to an electronic amplifier, anticipating what we would today call "wearable tech."

Like Futurism, the internet amounts to more than mere objects or images. It both reproduces and exacerbates power structures, however disembodied. The dream of universal accessibility, moreover, is widely undermined by anti-democratic tendencies. Those same tendencies may well find more sinister exploitation by Artificial Intelligence, which could not only obviate various professions and creative vocations but be used to control human subjects—or far worse still. The increasingly "generative" capacities of ChatGPT and digital image applications threaten to render human(ist) notions of authorship completely obsolete.

For his part, Marinetti hailed precisely the "inevitable identification of man and motor." He called for the "creation of an inhuman type," one in which "moral suffering, generosity, affect, and love will be abolished." Is it any surprise that today's die-hard advocates of AI and transhumanism take as their moniker "Evolutionary Futurists"? From climate change to biopolitics, several contemporary bugbears appear adumbrated in Futurist theory, if not always practice.

Yet what about the progressive legacies of Futurism's will to "progress"? In strictly economic and political terms, we find its ideological cocktail partially evinced in the left-wing movements of "creative destruction" and "accelerationism." It is a more broadly (counter-)cultural sphere on which Futurism has left its deepest marks, however. Some of these reflect the movement's ambivalence regarding technology and its relationship to capitalism. Andy Warhol's professed desire "to be a machine"—like his broader integration of multimedia pursuits

and marketing—extended Marinetti's imperatives regarding automation, as well as Depero's promotion of "self-advertising." Still more suggestive of Futurist precedent was Warhol's status as both a brand and a performance, an entrepreneur (editor, director, painter, photographer, producer) and living work of art. In ways related to Warhol's specifically American strain of Pop, neo-avant-garde artists in Italy in the 1960s appropriated new technologies as aesthetic media, which they hoped to exploit in critiquing larger social structures of commodification.

One of the post-war pioneers of Electronic Literature, Nanni Balestrini—whose experimental poems expressly reprised early Futurist typographic strategies—affirmed in a 1996 interview: "If the Futurists had had computers...they would have created their texts quicker, faster...their texts...are calling for the existence of a machine to do those things." Unlike the Dada movement, Futurism never ironized technology in any real political (or ontological) sense; its appropriation of mass media and machines sought not to question aesthetic genius per se but rather to refresh its sources. The Futurist influence upon modern industrial design, for example, is thus far more straightforward than that of Dada.

Yet its countercultural legacy—the revolt against conformity of all sorts—remains momentous in both original expression and afterlife. Of course, Futurism's gradual accommodation with Fascist authority (and authoritarianism) has long since conditioned its historical reception. One means of rescuing the movement from political taint after World War II was to cleave its earliest manifestations from subsequent efforts of the 1920s and 1930s, as the latter proved inextricable from interwar Fascist patronage and propaganda. The canonization of Umberto Boccioni and Antonio Sant'Elia during the 1930s as Futurist-Fascist martyrs—though they died well before the very existence of Fascism—compromised even the ideological thrust of early Futurism, however. The movement remained taboo for avant-garde

oriented artists, poets, and performers for decades after World War II. The critic Germano Celant briefly considered naming the Arte Povera movement he founded in 1967 "Neo-Futurism," yet rejected the name on ideological grounds.

Futurism could still be appreciated in strictly formalist terms. To wit, the artist and director Jack Clemente won the 1972 Venice Film Festival's Silver Lion for his documentary *Balla and Futurisme*. For all its striking evocations of Futurist imagery in post-war Italian society, the film skirted the political affinities of Balla and his colleagues. Closing with the image of someone playing a piano using a vacuum cleaner, the documentary evoked the movement's often playful anticipations of modern life, particularly in the wake of Italy's post-war economic "boom."

The later 1960s saw a more thorough resuscitation of Futurism in both art practice and historical research. On one hand, scholars began tackling the precise (and complex) relationship between Futurism and Mussolini's regime, lending nuance to the facile soundbites to which it had been reduced in historiography. On the other, neo-avant-garde artists began reprising Futurist strategies in performance and typographical experiments, musical compositions, and other media. Either bracketing these modes' often insidious ideological history or else repurposing them to left-progressive ends, a range of artists turned back to Futurism as an aesthetic (and often anti-aesthetic) touchstone.

A young generation of artists came to defy the increasingly commodified culture of post-war Europe and the United States. Yet they also assailed the kind of modernist formalism exemplified by Abstract Expressionism and Informalism—phenomena which agitated painterly surfaces while leaving deeper political hierarchies in place, reifying that agitation as a further commodity. Having profaned the ostensible purity of modernist media from its start, Futurism offered one paradigm for updating assaults on high culture.

The Fluxus movement of the 1960s and 1970s reactivated "historical" avant-garde activities and invented still others with interdisciplinary fervor, involving conceptual artists, composers, graphic designers, and video artists. Though equally indebted to Dada, the Fluxus practice of "intermedia"—a term coined by the British-born American artist Dick Higgins in the mid-1960s—traces some of its inspiration to Futurist models. Expanding performance into ever more mundane corners of real time and space, 1960s "Happenings" revived aspects of the Futurist *serate* which had purposefully blurred spectatorship and participation. Unlike the Futurist mobilization of performance for irredentist and interventionist politics, Happenings in 1960s and 1970s America and Europe often assumed an explicitly anti-war cast. This in no way diminished the salient links between art historical moments.

Michael Kirby's influential book *Futurist Performance* anthologized the written "scores" for various early Futurist events by 1971, while RoseLee Goldberg's *Performance Art: From Futurism to the Present* (1978) enshrined the group as the definitive originators of the avant-garde genre. More than any set of scripted acts, however, it was the open-endedness of Futurist ethos which informed post-war phenomena, from Umberto Eco's theory of the "Open Work" up through participatory art and "relational aesthetics." The latter's claim to comprise "the whole of human relations" remains debatable; its anticipation by the totalizing conceptual premise of the "Futurist Reconstruction of the Universe" is undeniable.

Other neo-avant-garde experiments relate more specifically to Futurist precedent. The musical composition and theory of John Cage reflect the avowed influence of Luigi Russolo's *The Art of Noises* (1916) (which Cage's sculptor wife Xenia began translating into English in the 1960s before abandoning the project). Even Cage's pathbreaking use of silence as a formative dimension of music echoes Marinetti's noise scores for the "Five Syntheses for

the Radiophonic Theater" in 1933—aural collages structured as much by the deployment of silence as by sound. Electronic experiments by the composer Walter Olmo have likewise been discussed in regard to Russolo's "noise intoners," while the development of "industrial painting" by his Situationist peer Giuseppe Pinot Gallizio bears out some further resonances, despite the vast ideological chasm separating Situationism from Marinetti's movement. As a chemist, pharmacist, painter, archaeologist, scientist, botanist, and dilettante herbalist, the Italian Gallizio embodied an interdisciplinarity inherited from Futurism—one he applied to a "unitary" activity in defiance of the hierarchical, specialized divisions of labor in which capitalism still widely traded.

Of course, late capitalist culture has increasingly absorbed into its cultural bloodstream even (or especially) the defiant elements of Futurism and other historical avant-gardes. Nowhere is that absorption more evident than in the domain of "design." The comprehensiveness of the term itself—encompassing now everything from architecture to digital applications—owes something to Futurism's aesthetic promiscuity. The notion of modern design comprising "the spoon to the city"—that is, the most minor of everyday appliances along with the most expansive—emerged as a key facet of Balla and Depero's "Futurist Reconstruction of the Universe." Futurism developed an approach to modernism as ideological and metaphysical as it was materialist. To put this another way, its artists sought not only to remake objects and images commensurate with modernity, but to revolutionize the mental sensibilities and social syntax that would make sense and use of modern phenomena. It is in part the Futurist project which gestated this approach to design as a sensibility rather than simply a vocation, a concept rather than a canon or practice.

Despite the pervasive (and specious) narrative of a post-war Italian design culture springing *ex nihilo* from the ashes of

Fascism (and a Marshall Plan-sponsored economic "miracle"), the nation's chief post-war cultural export had been incubated in the laboratory of Futurist ideas for decades. The innovations of Italian design were not limited to corporate and industrial strains, however. Though the postmodern and globalized conditions of late capitalism have long since neutralized their bite, the firms Archizoom and Superstudio developed a mordant praxis of "Radical Design" in late 1960s Italy. With projects like *No Stop City* (1970), Archizoom turned consumerist excess into a critique of its own effects. "The precise role of today's avant-garde," averred the architect Andrea Branzi in one contemporary text, is the "technical destruction of culture." Such imperatives relate to a broader Futurist precedent as much as they draw upon any particular avant-garde forms.

Futurism's contestatory and revolutionary legacies arguably play out across the full spectrum of 1960s cultural politics. Like many texts from the period, Susan Sontag's famous 1964 essay "Against Interpretation" bears the distinctive whiff of Futurist manifestos—not merely in its championing of an embodied intuition at the expense of the intellect, but in the performative incitement of its very language:

> The world, our world, is depleted, impoverished enough. Away with all duplicates of it, until we again experience more immediately what we have. The project of interpretation is largely reactionary...In a culture whose already classical dilemma is the hypertrophy of the intellect at the expense of energy and sensual capability, interpretation is the revenge of the intellect upon art. Even more. It is the revenge of the intellect upon the world.

As they engage with Futurist form, women authors, artists, and architects take revenge upon the movement's notorious misogyny. Structures by the late British-Iraqi architect Zaha Hadid—like her Jockey Club Innovation Tower in Hong Kong (2014) (Figure 33) or the Afragola train station in Naples (2017)—both recall and

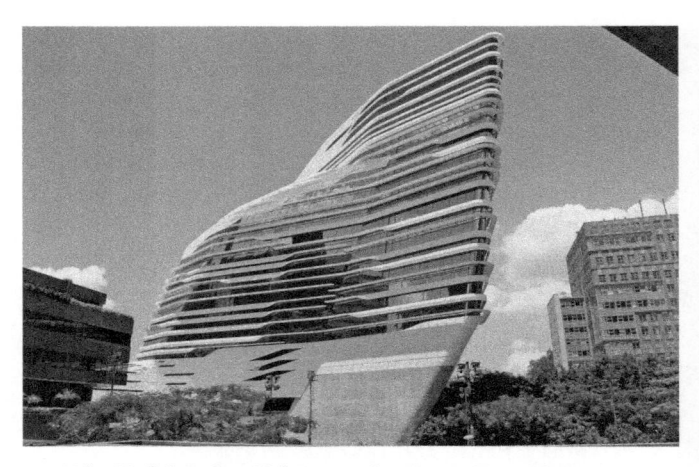

33. Zaha Hadid, Jockey Club Innovation Tower, Hong Kong, 2007–2013.

supersede the visionary delineations of Antonio Sant'Elia and other Futurist architects.

Titled *Conversation with Boxing Gloves* (2009), a video by the New York-based collective chameckilerner (founded by Rosane Chamecki and Andrea Lerner in 1992) restages a scene from the lost film *Vita Futurista* (1916) featuring Marinetti sparring with a male partner. Two women now box against a spare black backdrop, their figures dissolving into a vortex of almost pure form reminiscent of Futurist "simultaneity" and "interpenetration." Yet as the fight morphs into a Dionysian dance of sorts, the video undermines the virile belligerence both of the original scene and of Futurism more broadly.

More recently, the Greek artist, choreographer, and researcher Maria Sideri has reenacted the dance performances of the Futurist-affiliated Valentine de Saint Point, whose early manifestos carved out a vital space for women amid the

movement's professed "contempt for woman." Sideri's uses of oral history, memory, and archival records defy Futurist "anti-passéiste" dogma in their own right, though her critical revival of Saint Point's performance in *Vibrant Matter—The Métachorie* (2013) forges a specifically feminist afterlife for a work burdened by its own patriarchal weight. Sideri's accompanying texts trace parallels between female liberation movements and the anti-colonial Arab struggles in Syria and Egypt. She thus obliquely engages with the violent colonialist fantasies of the Egyptian-born Marinetti himself, from the fraught racial politics of his fictional *Mafarka the Futurist: An African Novel* (1909) through his very real service in Mussolini's vicious Ethiopian campaigns of the mid-1930s.

Like its cognates Post-Columbian Futurism, Indo-Futurism, and Indigenous Futurism(s), Afrofuturism constitutes a further creative strain of cultural "revenge" against Futurist chauvinism and imperialism. Its manifestations connect facets of African and Afro-diasporic cultures to various kinds of technological practice and imagination. The so-called "Dark Continent" served for centuries as the screen for all manner of Western colonialist projections, which flattened (and fetishized) myriad local histories as facile signifiers of backwardness and "primitiveness." Afrofuturism instead constellates disparate literary, cinematic, and musical practices as vectors of future-oriented imagination. Though the term is of relatively recent coinage, its impetus may be traced to a range of post-war phenomena: the videos and art direction of bands like Earth, Wind & Fire and Parliament Funkadelic; the collective experiments and self-stylings of the Jazz musician Sun Ra; the novels of Octavia Butler and Samuel R. Delany; and the Marvel comics character Black Panther, to name only a few (Figure 34). The eponymous 2018 film version of the latter by Disney Studios, like its recent sequel *Wakanda Forever*, risked mythicizing elements of African history in its celebration of Black futurity, reproducing some of the colonialist tropes it aimed to demystify.

34. Top: Missy Elliott, "The Rain" (Supa Dupa Fly) video, 1997;
Bottom: Earth, Wind & Fire, "Let's Groove," video, 1981.

Discussing his own turn to the relatively marginalized genre of science fiction since the 1960s, Delany has incisively addressed the construction of race itself as a biological fantasy, for which Blackness long provided the structurally subordinated term. He also highlights the perils of mistaking the trappings of futuristic commodities with access to the economic and cultural powers that produce them. It is the latter prospect that the most incisive strains of Afrofuturism reckon with, while simultaneously challenging the racist underpinnings of multinational capitalism—something Delany's work exemplifies in its resistance to facile formations of identity and nation. In a sense, Afrofuturism brings the African setting of Marinetti's *Mafarka* full circle, using some of the movement's creative innovations to upend its own nationalist and racist legacies.

Since the turn of the millennium, a striking range of contemporary artists—Candace Breitz, Tatsuo Miyajima, Dana Birnbaum, and Carsten Höller among them—have been discussed or exhibited in relationship to Futurist precedent. The sculptors Tony Cragg and Armen Agop evince Futurist imagery in incisively formalist terms, while the work of artists like williamCromar and Cornelia Parker instead conjure up provocatively ideological questions. Filling an entirely gallery with suspended, splintered detritus, Parker's *Cold Dark Matter: An Exploded View* (1991) recalls both the violence and the totalizing ambition of Boccioni's "sculpture of environment." The recent, global trend of digital "immersive experiences" evinces a similar ambition. Projecting (and sometimes animating) imagery by artists like Vincent Van Gogh, David Hockney, or Frida Kahlo across the walls and floor of empty rooms, these large-scale cybernetic installations realize the Futurist aim to "place the spectator in the center of the picture." Yet they also reify this ambition. Painting no longer becomes a site of truly embodied engagement but a kind of glorified wallpaper, a flashy backdrop for countless selfies.

Far more poignant are the environments created by an artist like Luca Buvoli, for instance, whose ironic reimagining of Futurist aeroaesthetic and other installations undertake what the artist calls a "re-reading of Futurism from a post-utopian perspective." Mounted at the 2009 Venice Biennale to mark the (ambivalent) centenary of Futurism, one such work featured Buvoli's single-channel video *Velocity Zero* (2007–09). Its suite of 11 scenes features an equal number of sufferers of aphasia—the brain disorder affecting speech (and often cognition)—as they read aloud the 11 points of Marinetti's "Founding and Manifesto of Futurism" with varying degrees of difficulty. Even as it protects the identity of these individuals, *Velocity Zero* lays bare the disparity between their strained efforts and the original Futurist fiats, inverting the poles of authority and incapacity bound up with the public utterance of language.

Futurism's founding manifesto fabricated out of sheer will a world unto itself. In the beginning was the modernist Word: a totality of language, a language of totality, upon which could be nourished an entire ideology in formation. From our 21st-century perch, the messianic tones of these pronouncements ring as errant as they are outdated. Particularly as reduced to quotable or tweetable soundbites, their absolutism seems either absurd in its assurance or (and?) to prefigure an increasingly polarized political discourse. Though much of its bracing innovation remains inextricable from often incendiary content, we still find in Futurism's history—despite itself—the glimmers of a different future.

References

Chapter 1: "Synthetic brevity"

Unless otherwise noted, all references to manifestos are to be found in
Futurism: An Anthology, ed. Lawrence S. Rainey, Christine Poggi,
and Laura Wittman (New Haven: Yale University Press, 2009).

"stupid to write…synthetic brevity": F. T. Marinetti, Emilio Settimelli,
and Bruno Corra, "The Futurist Synthetic Theater" (1915), 205,
206; "condense all of Shakespeare…": F. T. Marinetti, "The Variety
Theater" (1913), 163; "love of speed…": F. T. Marinetti, "Destruction
of Syntax—Radio Imagination—Words-in-Freedom" (1913), 145.

"architects of the future": Friedrich Nietzsche, *Untimely Meditations*,
trans. R. J. Hollingdale (Cambridge: Cambridge University Press,
1995), §94.

"land of the dead": Lamartine, in Christopher Duggan, *The Force of
Destiny: A History of Italy Since 1796* (Boston: Houghlin Mifflin,
2008), 117; "of a man who lives by exhibiting…": Joyce quoted in
Catherine Flynn, ed., *The New Joyce Studies* (Cambridge:
Cambridge University Press, 2022), 257.

"museums and cemeteries…": Bruno Corra and Emilio Settimelli,
"Weights, Measures, and Prices of Artistic Genius: Futurist Manifesto"
(1914), 186; "destroy museums…": F. T. Marinetti, "The Founding
and Manifesto of Futurism" (1909), 51; "elementary archaism…":
Umberto Boccioni, Carlo Carrà, Luigi Russolo, Giacomo Balla, and
Gino Severini, "Futurist Painting: Technical Manifesto" (1910), 67.

"When we are forty…": Marinetti, *The Founding and Manifesto of
Futurism*, 53; "Every generation": Antonio Sant'Elia, "Futurist
Architecture" (1914), 201.

"cult of the past…gouty academics": Umberto Boccioni, Carlo Carrà, Luigi Russolo, Giacomo Balla, and Gino Severini, "Manifesto of the Futurist Painters" (1910), 63; "Every day we must spit…": F. T. Marinetti, "A Response to Objections" (1912), 124.

"nothing is more terrible…": Boccioni cited in Mark Thompson, *The White War: Life and Death on the Italian Front 1915–1919* (New York: Basic Books, 2008), 236.

"We desperately want…": Boccioni et al., "Futurist Painting: Technical Manifesto," 65.

"finest Futurist poem": Marinetti, "In This Futurist Year" (1914), in Günter Berghaus, ed., *F. T. Marinetti: Critical Writings* (New York: Farrar, Straus & Giroux, 2006), 278.

"The Futurist moment…": Renato Poggioli, *The Theory of the Avant-Garde* (Cambridge, MA: The Belknap Press of Harvard University Press, 1981), 68.

Chapter 2: "Primitives of a new sensibility"

"burning and overwhelming…It is from Italy"; "We intend…"; "only hygiene…"; "violence, cruelty…": Marinetti, "Founding and Manifesto of Futurism," 52, 51, 53.

"revolutionary nationalism…clericalism": Marinetti, "Manifesto of the Futurist Political Party" (1918), in Berghaus, ed., *F. T. Marinetti: Critical Writings*, 317–22.

"intellectual clericalism": Marinetti, "Destruction of Syntax," 149.

"art of making manifestos": Marinetti cited in Marjorie Perloff, *The Futurist Moment: Avant-Garde, Avant Guerre, and the Language of Rupture* (Chicago: University of Chicago Press, 1986), 81.

"The discoveries contained…": Giacomo Balla and Fortunato Depero, "Futurist Reconstruction of the Universe" (1915), 212.

"begat from the dust…": Marinetti, "Ce qui nous sépare de Nietzsche," *Le Futurisme* (Paris: E. Sansot, 1911), 93–102; translated and reprinted as "Against Academic Teachers," in F. T. Marinetti, *Critical Writings*, ed. Günter Berghaus, trans. Doug Thompson (New York: Farrar, Straus & Giroux, 2006), 81.

"mobile spectator": Meyer Schapiro, "Nature of Abstract Art" (1937), in *Modern Art: 19th and 20th Centuries* (New York: George Braziller, 1978), 192.

"painting today…recourse only to Nature": Boccioni et al., "Futurist Painting: Technical Manifesto," 65, 66.

"passion for things": Marinetti, "Electric War" (1911), 99.

"labor, light, and movement": Boccioni cited in Christine Poggi, *Inventing Futurism: The Art and Politics of Artificial Optimism* (Princeton: Princeton University Press, 2008), 83.

"On account of the persistency…": Boccioni et al., "Futurist Painting: Technical Manifesto," 64.

"cinematograph in bellies…spliced cinematography": Allard and Pound cited in Edward Aiken, "The Cinema and Italian Futurist Painting," *Art Journal*, vol. 41, no. 4, Futurism (Winter, 1981), 353.

"Just as our forebears…": Boccioni et al., "Manifesto of the Futurist Painters," 62.

"obscure manifestations": "On account of the persistency…"; Boccioni et al., "Futurist Painting: Technical Manifesto," 65.

"breach the mysterious doors…": Marinetti, "The Founding and Manifesto of Futurism," 51.

"penetrate the true essence…By means of *intuition*": Marinetti in R. W. Flint, ed., *Marinetti: Selected Writings* (New York: Noonday, 1971), 112, and "Technical Manifesto of Futurist Literature" (1912), 124.

"We will solve…": Marinetti, "Beyond Communism" (1920), 263.

"idealism of Business…": Marinetti, "Destruction of Syntax," 144.

"The creator of Futurism…": Silvio Benco, in F. T. Marinetti, *The Untameables* [1922], trans. Jeremy Parzen (Los Angeles: Sun & Moon Press, 1994), n.p.

"We Italians need…": Umberto Boccioni, "Fondamento Plastico della Scultura e Pittura Futurista," *Lacerba*, no. 6 (Mar. 15, 1913), 51.

"I cannot free myself…": Franz Marc to Wassily Kandinsky, in Alan Bartram, *Futurist Typography and the Liberated Text* (New Haven and London: Yale University Press, 2005), 158.

"If our pictures…": Giacomo Balla, Umberto Boccioni, Carlo Carrà, Luigi Russolo, and Gino Severini, "The Exhibitors to the Public" (1912), 106.

Chapter 3: Early Futurist theory and practice

"What we have attempted"…"masked academicism"…"sum total": Giacomo Balla, Umberto Boccioni, Carlo Carrà, Luigi Russolo, and Gino Severini, "The Exhibitors to the Public (1912)," 105, 106.

"polyphonic tides": Marinetti, "Founding and Manifesto of Futurism," 51 (translation altered).

"With the desire to intensify…": "The Exhibitors to the Public," 107.

"In order to render a vortex...": Carlo Carrà, "The Painting of Sounds,
Noises, and Smells" (1913), 158.

"The principle of pictorial emotion...": Boccioni, *Futurist Painting
Sculpture (Plastic Dynamism)*, trans. Richard Shane Agin and
Maria Elena Versari (Los Angeles: Getty Research Institute,
2016), 51.

"thickened" present: Stephen Kern, *The Culture of Time and Space:
1880–1918* (Cambridge, MA: Harvard University Press, 1983).

"These days I am obsessed by sculpture!" ... "true bayonet attack":
Boccioni, in Ester Coen, ed., *Boccioni: A Retrospective* (New York:
Metropolitan Museum of Art, 1988), xxvii, 204.

"metallic...dermal resistance": Roberto Longhi, *Futurist Sculpture
Boccioni*, trans. Rosalind McKever and Lucinda Byatt, *Art in
Translation*, vol. 7, no. 3 (2015 [1914]), 325.

"physical transcendentalism": "The Exhibitors to the Public," 107.

"No one still believes"..."There is no such thing...": Boccioni, "Futurist
Sculpture" (1912), 115, 114.

"like a gigantic machine": Antonio Sant'Elia, "Futurist Architecture"
(1914), 200.

Chapter 4: From *Words-in-Freedom* to war

"How beautiful it is...": F. T. Marinetti, *La Bataille de Tripoli* (Milan:
Edizioni Futuriste di Poesia, 1912), 57.

"...2000 shrapnel...": F. T. Marinetti, cited in Luigi Russolo, "The Art
of Noises: Futurist Manifesto" (1913), 133.

"destroy the 'I' in literature...Be careful not to assign": Marinetti,
"Technical Manifesto of Futurist Literature" (1912), 122.

"Sun = vulcan + 3000 flags": Marinetti, "Battle Weight + Smell," in
"A Response to Objections" (1912), 128.

"decomposition of the image": Antonio Gramsci, "I Futuristi," *Corriere
Universitario* (Quindicinale dellassociazione Torinese
Universitaria), vol. 1, no. 8 (May 20, 1913).

"Will the war give us...": Prezzolini, cited in Walter L. Adamson,
Avant-Garde Florence: From Modernism to Fascism (Cambridge,
MA: Harvard University Press, 1993), chapter 4, "Culture Wars
and War for Culture: The Years of Florentine Futurism," 194;
"cleansing of the earth...": Giovanni Papini, in Adamson,
Avant-Garde Florence, 197.

"only through theater": F. T. Marinetti, Emilio Settimelli, and Bruno
Corra, "The Futurist Synthetic Theater" (1915), 204.

"live the war pictorially": Letter from Marinetti to Severini dated Nov. 20, 1914, cited in Christine Poggi, *In Defiance of Painting: Cubism, Futurism, and the Invention of Collage* (New Haven: Yale University Press, 1992), xiii.

Carrà's *Interventionist Demonstration (Patriotic Festival)* (1914); Willard Bohn, "Celebrating with Carlo Carrà: 'Festa patriottica,'" *Zeitschrift für Kunstgeschichte*, vol. 57, no. 4 (1994), 670–81; Flavio Fergonzi, "Carlo Carrà, *Interventionist Demonstration*," from *Masterpieces of the Mattioli Collection* (Milan: Skira, 2003), 205–09.

"Let's break out of wisdom": Marinetti, "Founding and Manifesto of Futurism," 50.

"Futurist poets, painters…": F. T. Marinetti, "The Futurist Political Movement" (1915), 216.

"herein lay the political tragedy…": Christopher Duggan, *A Concise History of Italy* (Cambridge: Cambridge University Press, 1984), 191.

"utterly dazzled": Fernand Léger, in Alexander Schouvaloff, ed., *The Art of Ballets Russes* (New Haven and London: Yale University Press, 1997), 248.

"a great remedy"; Henri Gaudier-Brzeska, *BLAST* no. 2, 1915 (War Number), 33.

"The War has exhausted…": Wyndham Lewis, "Marinetti's Occupation," *BLAST* no. 2, 1915 (War Number) 26.

"NON BASTA…": Mario Carli, in *Roma Futurista*, Nov. 4, 1918.

"laboratory": F. T. Marinetti, cited in *Giacomo Balla: La Modernità Futurista* (Milan: Skira, 2008), 133.

"capital of the new Italy": F. T. Marinetti, "The Free Word Style," introduction to *The Untameables*, trans. Jeremy Parzen, ed. Luigi Ballerini (Los Angeles: Sun & Moon Press, 1994 [1922]), 73.

Chapter 5: Futurist totality and intermediality

"There is no reason…": Corra and Settimelli, "Weights, Measures," 183.

"artificial distinctions": Umberto Boccioni, "The Plastic Foundations of Futurist Sculpture and Painting" (1913), 140.

"polyphonic": F. T. Marinetti, *Mafarka the Futurist: An African Novel*, trans. Carol Diethe and Steve Cox (London: Middlesex University Press, 1997), 1.

"current marvelous…"…"abstract equivalents": Balla and Depero, "Futurist Reconstruction of the Universe," 212, 209.

"polyphonic architectural...": Carlo Carrà, "The Painting of Sounds, Noises, and Smells," 158.

"reject the idea"..."Let's open up the figure...": Boccioni, "Futurist Sculpture," 118, 117.

"Metal wires...": Balla and Depero, "Futurist Reconstruction of the Universe," 210.

"ideal nutriment": Marinetti, "Beyond Communism" (1920), 263.

"A typewriter is *more architectural*...": Giacomo Balla, "The Futurist Universe," in Umbro Apollonio, ed., *Futurist Manifestos* (London: Thames and Hudson, 2001), 219; emphasis in original.

"a single city": Volt (Vincenzo Fani Ciotti), "La casa futurista: manifesto" (May 1920), reprinted in Volt, *La fine del mondo*, ed. Gianfranco de Turris (Florence: Vallecchi, 2003).

Chapter 6: Futurism and gender

"contempt for woman": Marinetti, "Founding and Manifesto of Futurism," 51.

"a certain doubt": Jane Catulle-Mendès cited in Günter Berghaus, "Futurism and Women: A Review Article," *The Modern Language Review*, vol. 105, no. 2 (Apr. 2010), 402.

"tyranny of love": Lucia Re, "Futurism and Feminism," *Annali d'Italianistica*, Women's Voices in Italian Literature, vol. 7 (2011), 255.

"We feel contempt...": Marinetti, "Contempt for Woman" (1911), Selections from *Le Futurisme* (1911), translated as *Guerra, sola igiene del mondo* (1915), 86.

"effeminate fuss": Boccioni, "Futurist Sculpture," 113; "procuress": F. T. Marinetti, Umberto Boccioni, Carlo Carrà, and Luigi Russolo, "Against Passéist Venice" (1910), 68.

"[I]f the family": Marinetti, "Contempt for Woman" (1911), 89.

"unpracticed ovary...radiate will": Marinetti, *Mafarka the Futurist*, 3, 43.

"WHAT WE MOST NEED...warriors who fight": Valentine de Saint-Point, "Manifesto of the Futurist Woman (Response to F. T. Marinetti)" (1912), 110, 111.

"to kill the weak...": Valentine de Saint-Point, "Futurist Manifesto of Lust" (1913), 132.

Mina Loy, "Feminist Manifesto" (1914), in Jane Goldman, Olga Taxidou, Vassiliki Kolocotroni, eds., *Modernism: An Anthology of*

Sources and Documents (Chicago: University of Chicago Press, 1998), 258–61.

"strong, VIRILE…": Enif Robert, *A Tranquil Thought* (1917), 234; Rosà, *A Woman with Three Souls*, trans. Lucia Re and Dominic Siracusa, *California Italian Studies*, vol. 2, no. 1 (2011); on *L'Italia Futurista*, see Adamson, *Avant-Garde Florence: From Modernism to Fascism* (Cambridge, MA: Harvard University Press, 1993); Enif Robert and F. T. Marinetti, *Un ventre di donna: romanzo chirurgico* (Milan: Facchi, 1919).

"It will suffice…": Volt (Vincenzo Fani Ciotti), "Futurist Manifesto of Women's Fashion," *Roma Futurista*, Feb. 29, 1920; translated in Emily Braun, "Futurist Fashion: Three Manifestos," *Art Journal*, vol. 54, no. 1 (Spring, 1995), 34–41; "In the name of real Futurist women": Anonymous, "Una donna futurista da quasi sette anni: Una lettera a Volt," *Roma Futurista*, vol. 2, no. 36 (Aug. 31, 1919).

"as when a child is born": Růžena Zátková, Letter to her sister Sláva, Feb. 2, 1918; reproduced in Giorgini, *Růžena Zátková: Un'artista boema nel futurismo italiano*, Doctoral thesis, Università della Sapienza di Roma, 2011, 289; "super virility": Prampolini, "Rugena Zatkovà," *Il Centauro*, vol. 2, no. 2 (Feb. 1923), 79; Marinetti, Letter, Feb. 1921, cited in Günter Berghaus, "Růžena Zátková: An 'Atypical' Futurist," in Günter Berghaus, ed., *International Yearbook of Futurism Studies* (Berlin: De Gruyter, 2011), 12: "typical…" Marinetti, Letter of Feb. 1921, cited in Berghaus, "Růžena Zátková," 12.

"For me, Futurism is…": Alena Pomajzlová, "The Czech Lands," in Günter Berghaus, ed., *Handbook of International Futurism* (Berlin: De Gruyter, 2019), 387.

"a useful death…": Benedetta, "Progetto futurista di reclutamento per la prossima guerra," *Futurismo*, Rome, vol. 1, no. 4 (Oct. 2, 1932), 1.

"fertile female womb…": Ambrosi, "Maternità aeronautica," *41 pittori futuristi* (1931), cited in *Italian Futurism and the Machine* (Manchester: University of Manchester Press, 2019), 243.

"dismal, ridiculous condemnation…": F. T. Marinetti, "Futurist Speech to the English" (1910), 72.

"absolutely modernist-Futurist!": Ardengo Soffici, Letter to Carlo Carrà, May 22, 1913, cited in Ara H. Merjian, "'An Applied Physiology': Italian Modernism, Nietzschean Philosophy, and the Sexual Economy of Style," *Res: Anthropology and Aesthetics*, nos. 65–66 (Spring 2015), 387–402.

"nothing more natural…": Italo Tavolato, *Contro la morale sessuale* (Florence: Gonnelli, 1913).

"In the name of the great…": "Against Feminine Luxury" (1920), trans. Chris Turner, *Cultural Politics*, vol. 14, no. 1 (2018), 90–94.

"effeminate…influence of foreign art": Galli cited in Tommaso Mozzati, "Contro le rose d'aprile: Galli, il Futurismo e i discorsi sull'omosessualità," in *Gino Galli, 1893–1944: La riscoperta di un pittore tra Futurismo e Ritorno all'ordine* (Rome: MLAC, 2023).

Chapter 7: Futurisms, plural

"With millions of manifestos…": F. T. Marinetti, "The Futurist Political Movement" (1915), 216.

"Throw Pushkin…": Roland Greene, ed., *The Princeton Encyclopedia of Poetry and Poetics* (Princeton: Princeton University Press, 2012), 1235.

Natalia Goncharova and Mikhail Larionov, "A Manifesto" (1913), in Mary Ann Caws, ed., *Manifesto: A Century of Isms* (Lincoln, NE: University of Nebraska Press, 2001).

"The only freedom…": Khlebnikov, cited in Perloff, *The Futurist Moment*, 22.

"one of the alternative terms…": Walter Michel, ed., *Wyndham Lewis: Paintings and Drawings* (Chicago: University of Chicago Press, 1971), 22.

"chauvinism": Aldo Palazzeschi, Ardengo Soffici, and Giovanni Papini, "Futurismo e Marinettismo," *Lacerba*, vol. 3, no. 7 (Feb. 14, 1915), 49–51.

Alfred Döblin, "Die Bilder der Futuristen," *Der Sturm*, May 1912; in *Kleine Schriften* (Olten: Walter Verlag, 1985), 112–17.

On Frances Simpson Stevens, see Carolyn Burke and Naomi Sawelson-Gorse, "In Search of Frances Simpson Stevens," *Art in America*, vol. 82, no. 4 (1994), 106–15; on Stella, see Barbara Haskell, *Joseph Stella* (New York: Whitney Museum, 1994).

"Dada was born…": Tristan Tzara, "Dada manifesto" (1918), in Dawn Ades, ed., *The Dada Reader: A Critical Anthology* (London: Tate, 2006), 36–42.

"I am an Italian Futurist poet…": F. T. Marinetti and Christopher Nevinson, "Futurism and English Art" (1914), 196.

Pontus Hultén, ed., *Futurism & Futurisms (Futurismo & Futurismi)* (Milan: Bompiani, 1986).

"Russian Futurists are…": Marinetti, "Beyond Communism"
(1920), 263.

F. T. Marinetti, "Contro l'esterofilia: manifesto futurista alle signore e
agli intellettuali", in Marinetti and Fillìa, *La cucina futurista*
(Milan: Sonzogno, 1932).

On Marinetti's correspondence with Kandinsky, see Monica Cioli,
"The European Avant-Gardes and Italian Fascism: The
Kandinsky–Marinetti Correspondence in July 1932," *Themenportal
Europäische Geschichte*, 2017, <www.europa.clio-online.de/essay/
id/fdae-1698>.

On Marinetti's return to Egypt in the 1930s, see Sam Bardaouil,
Surrealism in Egypt: Modernism and the Art and Liberty Group
(London: Bloomsbury, 2016).

Chapter 8: "Second" Futurism and the Fascist regime

"The possibility…": Reyner Banham, *Theory and Design in the First
Machine Age* (Cambridge, MA: MIT Press, 1996 [1960]), 135.

"evident that Futurism…": Maurizio Fagiolo Dell'Arco, "The Futurist
Reconstruction of the Universe", in *The New Italian Landscape*
(New York: MoMA, 1972), 293.

"'second' Futurism": Enrico Crispolti, *Il Secondo Futurismo: 5 pittori +
1 scultore* (Turin: Pozzo, 1962).

"Futurism is a great anti-philosophical…"; Futurism and Fascism:
F. T. Marinetti, *Futurismo e Fascismo* (Foligno: Campitelli, 1924).

"Fascism as an idea…": Sergio Pannunzio, "The Two Faces of Fascism,"
in *A Primer of Italian Fascism*, ed. Jeffrey Schnapp, trans. Olivia
Sears (Lincoln, NE: University of Nebraska Press, 2000),
88–94, 89.

"The Futurists have carried out…": Antonio Gramsci, "Marinetti the
Revolutionary," *Ordine Nuovo*, Jan. 1921, in David Forgacs, ed.,
The Gramsci Reader: Selected Writings 1916–1935 (New York:
NYU Press, 2000), 73–5.

Aeropainting and aeroaesthetics, and Fascist politics, see Franco
Ragazzi, "Futurism and Fascism: The Words and Images of
Aeropainting," in Silvia Barisione, Matteo Fochessati, and Gianni
Franzone, eds., *Parole e Immagini Futuriste dalla Collezzione
Wolfson* (Milan: Mazzotta, 2001), 163–75; Willard Bohn, "The
Poetics of Flight: Futurist 'Aeropoesia,'" *MLN*, vol. 121, no. 1,
Italian Issue (Jan. 2006), 207–24.

1932 Exhibition of the Fascist Revolution: Jeffrey T. Schnapp, "Fascism's Museum in Motion," *Journal of Architectural Education*, vol. 45, no. 2 (Feb. 1992), 87–97; Marla Stone, *The Patron State: Culture and Politics in Fascist Italy* (Princeton: Princeton University Press, 1998); Vanessa Rocco, *Photofascism: Photography, Film, and Exhibition Culture in 1930s Germany and Italy* (London: Bloomsbury, 2020).

Futurist "Mechanical Art": Günter Berghaus, ed., *Futurism and the Technological Imagination* (Leiden, Brill, 2009), 263–86; Christine Poggi, "Ivo Pannaggi: *Meccano-Futurista*, Constructivist, Proletarian," in Vivien Greene, ed., *Reconstructing the Universe: Italian Futurism, 1909–1944* (New York: Guggenheim, 2014); Katia Pizzi, *Italian Futurism and the Machine* (Manchester: University of Manchester Press, 2019).

"All-rice…": F. T. Marinetti, *The Futurist Cookbook* (New York: Penguin, 2015 [1932]).

"Futurist Manifesto of the Italian Hat," by F. T. Marinetti, translated in Braun, "Futurist Fashion: Three Manifestos," 40–41.

"As an alliance of artists…an Art of the State": Fillia (Luigi Colombo), "Rapporti tra Futurismo e Fascismo," 1930; reprinted 1980 (Florence: Spes-Salimbeni), p. 196.

"not one school…": Marinetti, cited in Berghaus, *Futurism and Politics*, 63.

Chapter 9: Empire, race, war (again)

"prized…predominantly hostile": Stone, *The Patron State*; Günter Berghaus, *Futurism and Politics: Between Anarchist Rebellion and Fascist Reaction, 1909–1944* (Providence, RI: Berghahn Books, 1996).

F. T. Marinetti, "La guerra futura," in *Futurismo*, Jan. 29, 1933, in Ernest Ialongo, *Filippo Tommaso Marinetti: The Artist and His Politics* (Madison, NJ: Fairleigh Dickinson University Press, 2015).

"We Futurists declare…": Giacomo Balla, Benedetta, Fortunato Depero, Gerardo Dottori, Fillia, F. T. Marinetti, Enrico Prampolini, Mino Somenzi, and Tato, "Manifesto of Aeropainting" (1929), 283.

Fillia, *Fascist Art: Elements for Artistic Battle*: Adriana M. Baranello, "*Arte sacra futurista*: Fillia Between Conformity and Subversion," *California Italian Studies*, vol. 5, no. 1 (2014).

"aviational inflection": Renato Di Bosso and Ignazio Scurto, "Manifesto futurista sulla cravatta italiana" ("Manifesto of the Italian Necktie") (1933) (Verona: Industria Grafica Manzini e Torresani, 1933).

"African (and simply colonial)...": F. T. Marinetti, "Futuristi Italiani," *Prima Mostra Internazionale d'Arte Coloniale* (Rome: Palazzo degli Esposizioni, 1931), 291.

"future aerial-chemical": Benedetta, "Progetto futurista di reclutamento per la prossima guerra," *Futurismo*, Rome, vol. 1, no. 4 (Oct. 2, 1932), 1.

"barbarian, anti-Italian...": Ardengo Soffici, *Critica Fascista*, Oct. 1926, trans. in *A Primer of Italian Fascism*, 208.

Marinetti, "The Italian Army," *L'Esercito italiano: Poesia armata* (Milan: Cenacolo, 1942).

"involuntary convergence": Francesco Bruno, "D'Annunzio e il Futurismo," *Mediterraneo Futurista*, vol. 2, no. 1 (Mar. 27, 1938).

"Italy, absolute and sovereign...": "Futurist Political Program," 1913, trans. in Marinetti, "The Futurist Political Movement" (1915), 218.

"individualists...": Benito Mussolini, "Foundations and Doctrines of Fascism" (1932), in *A Primer of Italian Fascism*, 47–71.

Chapter 10: The futures of Futurism

"Put your trust...": Marinetti, "Electric War: The Birth of a Futurist Aesthetic" (1911), Selections from *Le Futurisme* (1911), 100.

"Our renewed consciousness...": Boccioni et al., "Manifesto of the Futurist Painters," 65.

"notion that Futurism...": Maurizio Calvesi, "Un pensiero concretto II," *Marcatre*, vols. 16/17/18 (1965), 241.

"If the Futurists had had computers...": Nanni Balestrini, cited Matteo d'Ambrosio, "From Words-in-Freedom to Electronic Literature: Futurism and the Neo-Avantgarde," in Berghaus, ed., *Futurism and the Technological Imagination*, 263–86.

"The precise role...": Andrea Branzi, "La Gioconda Sbarbata" ("The Shaved Mona Lisa"), *Casabella*, no. 363 (Mar. 1972).

"The world, our world": Susan Sontag, "Against Interpretation" (1964), in *Against Interpretation* (New York: Farrar, Straus & Giroux, 1966).

Further reading

Chapter 2: "Primitives of a new sensibility"

On Futurism's intellectual and aesthetic origins
Caroline Tisdall and Angelo Bozzolla, "The Roots of Futurism," in
Futurism (London: Thames and Hudson, 1977), ch. 2;
Ara H. Merjian, "An Older Future: Gabriel Alomar's *El Futurisme*
(1904)," *Modernism/Modernity*, vol. 17, no. 2 (Apr. 2010); Geert
Buelens, Harald Hendrix, and Michelangela Monica Jansen, eds., *The
History of Futurism: The Precursors, Protagonists, and Legacies* (New
York: Lexington Books, 2012); Rosalind McKever, "On the Uses of
Origins for Futurism," *Art History*, vol. 39, no. 3 (Feb. 2016).

On and by F. T. Marinetti
R. W. Flint, ed., *Marinetti: Selected Writings* (New York:
Noonday, 1971); Günter Berghaus, *The Genesis of Futurism:
Marinetti's Early Career and Writings 1899–1909* (Leeds: Society of
Italian Studies, 1995); Cinzia Blum, *The Other Modernism:
F. T. Marinetti's Futurist Fiction of Power* (Berkeley: University
of California Press, 1996); F. T. Marinetti, *Selected Poems and Related
Prose*, trans. Elizabeth R. Napier and Barbara R. Studholme (New
Haven: Yale University Press, 2003).

On Futurism and music
Luigi Russolo, *The Art of Noises*, ed. and trans. Barclay Brown (New
York: Pendragon, 1986);Luciano Chessa, *Luigi Russolo, Futurist
Noise, Visual Arts, and the Occult* (Berkeley: University of California
Press, 2012); Luigi Russolo, Francesco Balilla Pratella, and

F. T. Marinetti, *The Art of Noise: Destruction of Music by Futurist Machines* (Deicide Press, 2023).

On Futurism and architecture

Reyner Banham, *Theory and Design in the First Machine Age* (Cambridge, MA: MIT Press, 1996 [1960]); Esther Da Costa Meyer, *The Work of Antonio Sant'Elia: Retreat into the Future* (New Haven and London: Yale University Press, 1995); Esther Da Costa Meyer, "Drawn into the Future: Urban Visions by Mario Chiattone and Antonio Sant'Elia," in *Reconstructing the Universe: Italian Futurism, 1909–1944* (New York: Guggenheim, 2014).

Chapter 3: Early Futurist theory and practice

On early Futurist art and theory

Max Kozloff, *Cubism/Futurism* (New York: Icon Editions, 1973); Marianne Martin, *Futurist Art and Theory, 1909–1915* (Michigan: Hacker Art Books, 1978); Laura Mattioli, ed., *Boccioni: pittore scultore futurista* (Milan: Skira, 2006); Christine Poggi, *Inventing Futurism: The Art and Politics of Artificial Optimism* (Princeton: Princeton University Press, 2008); Vivien Greene, ed., *Reconstructing the Universe: Italian Futurism, 1909–1944* (New York: Guggenheim, 2014); Elza Adamowicz and Simona Storchi, eds., *Back to the Futurists: The Avant-Garde and Its Legacy* (Manchester: Manchester University Press, 2014); Umberto Boccioni, *Futurist Painting Sculpture*, trans. Richard Shane Agin and Maria Elena Versari (Los Angeles: Getty Research Institute, 2016 [1914]); Ara H. Merjian, *Fragments of Totality: Futurism, Fascism, and the Sculptural Avant-Garde* (New Haven: Yale University Press, 2024).

Chapter 4: From *Words-in-Freedom* to war

On Futurism and World War I

Caroline Tisdall and Angelo Bozzolla, "Art of the War Years and After," in *Futurism* (London: Thames and Hudson, 1977), ch. 10, pp. 177–91; Linda Landis, "Futurists at War," in *The Futurist Imagination: Word + Image in Italian Futurist Painting, Drawing, Collage and Free-Word Poetry*, ed. Anne Coffin Hanson (New Haven: Yale University Art Gallery, 1983); Lucia Re, "Rosa Rosà and the Question of Gender in Wartime Futurism," in Vivien Greene, ed., *Italian Futurism*

1909–1944: Reconstructing the Universe (New York: Guggenheim), 184–87; Maria Elena Versari, "Avant-Garde Iconographies of Combat: From the 'Futurist Synthesis of War' to 'Beat the Whites with the Red Wedge'", *Annali d'Italianistica*, vol. 33 (2015), 187–204; Selena Daly, *Italian Futurism and the First World War* (Toronto: University of Toronto Press, 2016).

On Futurist literature and typography

Anne Coffin Hanson, ed., *The Futurist Imagination: Word and Image in Italian Futurist Painting, Drawing, Collage and Free-Word Poetry* (New Haven: Yale University Art Gallery, 1983); Jeffrey T. Schnapp, "Politics and Poetics in Marinetti's Zang Tumb Tuuum," *Stanford Italian Review*, vol. 5, no. 1 (Spring 1985), 75–92; John J. White, *Literary Futurism: Aspects of the First Avant-Garde* (Oxford: Clarendon Press, 1990); Johanna Drucker, *The Visible Word: Experimental Typography and Modern Art, 1909–1923* (Chicago: University of Chicago Press, 1994); Jeffrey Schnapp, "Propeller Talk," *Modernism/Modernity*, vol. 1, no. 3 (Sept. 1994), 153–78; Willard Bohn, ed., *Italian Futurist Poetry* (Toronto: University of Toronto Press, 2005).

Chapter 5: Futurist totality and intermediality

On Futurist intermedia, performance, and theater

Günter Berghaus, *Italian Futurist Theatre, 1909–1944* (Oxford: Clarendon Press, 1998); "The Futurist Re-Fashioning of the Universe," *South Central Review*, vol. 13, nos. 2–3 (Summer–Fall 1996), 82–104; Michael Kirby, *Futurist Performance* (Cambridge, MA: MIT Press, 2001 [1971]); RoseLee Goldberg, *Performance Art: From Futurism to the Present* (New York: Thames and Hudson, 2011 [1978]); Günter Berghaus, "Fortunato Depero and the Theatre," in *Fortunato Depero*, monographic issue of *Italian Modern Art*, vol. 1 (Jan. 2019).

On Futurist design and environments

Enrico Crispolti, ed., *Casa Balla e il Futurismo a Roma* (Rome: Istituto Poligrafico e Zecca dello Stato, 1989); Ara H. Merjian, "A Future by Design: Giacomo Balla and the Domestication of Transcendence," *Oxford Art Journal*, vol 35, no. 2 (2012), 121–46; Vivien Greene, "The *Opera d'Arte Totale*," in Vivien Greene, ed., *Reconstructing the Universe: Italian Futurism, 1909–1944* (New York:

Guggenheim, 2014), 210–19; Domitilla Dardi and Bartolomeo Pietromarchi, *Giacomo Balla: Casa Balla: From the House to the Universe and Back Again* (Rome: Marsilio/MAXXI, 2021).

On Futurist photography and cinema
Giovanni Lista, *Futurism and Photography* (London: Merrell Publishers, 2003); Rossella Catanese, ed., *Futurist Cinema: Studies on Italian Avant-Garde Film* (Amsterdam: Amsterdam University Press, 2017).

Chapter 6: Futurism and gender

On women and/in the Futurist movement
Claudia Salaris, *Le futuriste: Donne e letteratura d'avanguardia in Italia (1909/1944)* (Milan: Edizione delle Donne, 1982); Mirella Bentivoglio and Franca Zoccoli, *Women Artists of Italian Futurism— Almost Lost to History* (New York: Midmarch Arts Press, 1997); Lisa Panzera, ed., *La Futurista: Benedetta Cappa Marinetti* (Philadelphia: Moore College, 1998); Lucia Re, "Mina Loy and the Quest for a Futurist Feminist Woman," *The European Legacy: Toward New Paradigms*, vol. 14, no. 7 (2009), 799–819; Lucia Re, "Rosa Rosà's Futurist-Feminist Short Novel *A Woman With Three Souls*: A Critical Introduction," *California Italian Studies*, vol 2, no. 1 (2014); Günter Berghaus, "Růžena Zátková: An 'Atypical' Futurist," in Berghaus, ed., *International Yearbook of Futurist Studies* (Berlin: De Gruyter, 2015); Paola Sica, *Florence, Feminism and the New Sciences* (London: Palgrave, 2015); Lisa Hanstein, "Edyth von Haynau, Edyth Arnaldi and Rosa Rosà: One Woman, Many Souls," in *Gender Dimensions in Max Planck Research Projects* (Baden-Baden: Nomos, 2021), 43–64; Jennifer Griffiths, *Marisa Mori and the Futurists: A Woman Artist in an Age of Fascism* (London: Bloomsbury, 2023).

On Futurism and homosexuality
F. T. Marinetti and Bruno Corra, *L'Isola dei baci (The Island of Kisses)* (Milan: Studio Lombardo, 1918); Emma Van Ness, "(No) Queer Futurism: Prostitutes, Pink Poets, and Politics in Italy from 1913–1918," *Carte Italiane*, vol. 6 (2010), 169–86; Mauro Pasqualini, "Contesting Sexual Morality: Futurism, Masculinity, and Homosexuality in Florence, 1913–1914," *Storicamente*, no. 9 (2013), 2–25.

Chapter 7: Futurisms, plural

On international Futurist currents

Anne D'Harnoncourt and Germano Celant, eds., *Futurism and the International Avant-Garde* (Philadelphia Museum of Art, 1980); Pontus Hulton, ed., *Futurism and Futurisms* (Venice: Palazzo Grassi, 1986); Günter Berghaus, ed., *International Futurism in Arts and Literature* (Berlin: De Gruyter, 2000); Maria Elena Versari, "Enlisting and Updating: Ruggero Vasari and Futurism in Eastern and Central Europe," in Günter Berghaus, ed., *International Yearbook of Futurist Studies* (Berlin: De Gruyter, 2001), 277–98; Ester Coen, ed., *Futurismo 100: Illuminazioni A confronto: Italia, Germania, Russia* (Italian, German, and Russian edition) (Milan: Electa, 2009) [English edition: *Futurism* (Five Continents Editions, 2009)]; Günter Berghaus, *Handbook of International Futurism*, multiple volumes (Berlin: De Gruyter, 2011–23).

On Futurism and Cubo-Futurism in Russia

Vladimir F. Markov, *Russian Futurism: A History* (Washington, DC: New Academia Publishing, 2006 [1968]); John Milner, *A Slap in the Face! Futurists in Russia* (London: Bloomsbury, 2007); John E. Bowlt, ed., *Russian Art of the Avant-Garde: Theory and Criticism* (London: Thames and Hudson, 2017); Anna Lawton and Herbert Eagle, eds., *Words in Revolution: Russian Futurist Manifestoes 1912–1928* (Washington, DC: New Academia Publishing, 2014); Günter Berghaus, Oleh S. Ilnytzkyj, Gabriella Elina Imposti, and Christina Lodder, eds., *International Yearbook of Futurist Studies*, special issue: *Russian Futurism* (Berlin: De Gruyter, 2019).

Chapters 8 and 9: "Second" Futurism and the Fascist regime *and* Empire, race, war (again)

On "Second" Futurism and "Mechanical Art"

Enrico Crispolti, *Il secondo futurismo, Torino 1923–1938* (Turin: Edizioni d'arte Fratelli Pozzo, 1961); Gerald Silk, "'Il Primo Pilota': Mussolini, Fascist Aeronautical Symbolism, and Imperial Rome," in Claudia Lazzaro and Roger J. Crum, eds., *Donatello Among the Blackshirts: History and Modernity in the Visual Culture of Fascist Italy* (Ithaca, NY: Cornell University Press, 2005); Günter Berghaus, ed., *Futurism and the Technological Imagination* (Leiden: Brill,

2009), 263–86; Katia Pizzi, *Italian Futurism and the Machine* (Manchester: University of Manchester Press, 2019).

On Futurism and Fascism

Jeffrey Schnapp, "Forwarding Address," *Stanford Italian Review*, vol. 8, no. 1.2 (1988), 53–80; Renzo De Felice, ed., *Futurismo, cultura, e politica* (Turin: Fondazione Agnelli, 1988); Claudia Salaris, *Artecrazia: L'avanguardia futurista negli anni del fascimo* (Florence: La Nuova Italia Editrice, 1992); Barbara Spackman, *Fascist Virilities: Rhetoric, Ideology, and Social Fantasy in Italy* (Minneapolis: University of Minnesota Press, 1996); Matthew Affron and Mark Antliff, eds., *Fascist Visions: Art and Ideology in France and Italy* (Princeton: Princeton University Press, 1997); Emilo Gentile, *The Struggle for Modernity: Nationalism, Futurism, and Fascism* (London: Praeger, 2003); Ara H. Merjian, *Fragments of Totality: Futurism, Fascism, and the Sculptural Avant-Garde* (New Haven: Yale University Press, 2024).

On Futurism and politics

Giovanni Lista, *Arte e politica: Il futurismo di sinistra in Italia* (Milan: Multhipla Edizioni, 1980); Umberto Carpi, *Bolscevico immaginista: Comunismo e avanguardie artistiche nell'Italia degli anni venti* (Naples: Luguori, 1981); Matthew Affron and Mark Antliff, eds., *Fascist Visions: Art and Ideology in France and Italy* (Princeton: Princeton University Press, 1997), 73–99; Mark Antliff, "The Fourth Dimension and Futurism: A Politicized Space," *Art Bulletin*, vol. 82, no. 4 (Dec. 2000), 720–33; Mark Antliff, *Sculptors Against the State: Anarchism and the Anglo-European Avant-Garde* (University Park: Penn State Press, 2021).

On Futurism, colonialism, and imperialism

F. T. Marinetti, "Futuristi Italiani," in *Prima Mostra Internazionale d'Arte Coloniale* (Rome: Palazzo degli Esposizioni, 1931); F. T. Marinetti, *Il poema africano della Divisione "28 ottobre"* (Milan: Mondadori, 1937); Lucia Piccioni, "L'Aeropittura Futurista e colonialismo fascista: Il paesaggio africano senza l'uomo," *Mitteilungen des Kunsthistorischen Institutes in Florenz*, vol. 59, no. 1, Visualizing Otherness in Modern Italy (XIX–XX Century) (2017).

Chapter 10: The futures of Futurism

On Afrofuturism

"Black to the Future: Interviews with Samuel R. Delany, Greg Tate, and Tricia Rose," in Mark Dery, ed., *Flame Wars: The Discourse of Cyberculture* (Durham, NC: Duke University Press, 1994); Ytasha L. Womack, *Afrofuturism: The World of Black Sci-Fi and Fantasy Culture* (New York: Lawrence Hill Books, 2013); Isiah Lavender III, *Afrofuturism Rising: The Literary Prehistory of a Movement* (Columbus, OH: Ohio State University Press, 2019); Reynaldo Anderson and Clinton R. Fluker, eds., *The Black Speculative Arts Movement Black Futurity, Art + Design* (New York: Lexington Books, 2019).

On afterlives in aesthetics and scholarship

Daniele Lombardi, "Futurism and Musical Notes," *Artforum*, vol. 19, no. 5 (Jan. 1981); Giacinto Di Pietrantonio and Maria Cristina Rodeschini, eds., *The Future of Futurism* (Bergamo: Galleria di Arte Moderna e Contemporanea di Bergamo, 2008); Ara H. Merjian, "'Those ars all bellical': Luca Buvoli's *Velocity Zero* (2007–2009), Futurism, and a Post/Modernist Poetics of Aphasia," *Word & Image*, vol. 28, no. 2 (Fall 2012), 101–16; Helen Palmer, *Deleuze and Futurism: A Manifesto for Nonsense* (London: Bloomsbury, 2014); Andrew Pilsch, *Transhumanism: Evolutionary Futurism and the Human Technologies of Utopia* (Minneapolis: University of Minnesota Press, 2017); Mikhail Epstein, "A Futurist Turn in the Humanities," *College Literature*, vol. 48, no. 3 (Summer 2021), 593–622; Chelsea Vowel, "Writing Toward a Definition of Indigenous Futurism," *Literary Hub* (June 10, 2022), <https://lithub.com/writing-toward-a-definition-of-indigenous-futurism/>.

Index

Since the index has been created to work across multiple formats, indexed terms for which a page range is given (e.g., 52–53, 66–70, etc.) may occasionally appear only on some, but not all of the pages within the range.

Futurism

Index

MODERN ITALY
A Very Short Introduction
Anna Cento Bull

The history of modern Italy is characterized by rejuvenation and regeneration, often with roots in a widespread dissatisfaction with social and political reality, and perceived moral corruption. In the last 25 years a project of modernization epitomized by Silvio Berlusconi has characterized Italian politics. This has brought about the mixing of nationalist themes with the embracing of consumer and media culture.

Considering Italy's political system, style of government, and economic modernisation, as well as looking at Italian culture and lifestyle, Anna Cento Bull addresses the question of what modernity means to Italy, and asks what modern Italy stands for.

FILM
A Very Short Introduction
Michael Wood

Film is considered by some to be the most dominant art form of the twentieth century. It is many things, but it has become above all a means of telling stories through images and sounds. The stories are often offered to us as quite false, frankly and beautifully fantastic, and they are sometimes insistently said to be true. But they are stories in both cases, and there are very few films, even in avant-garde art, that don't imply or quietly slip into narrative. This story element is important, and is closely connected with the simplest fact about moving pictures: they do move. In this *Very Short Introduction* Michael Wood provides a brief history and examination of the nature of the medium of film, considering its role and impact on society as well as its future in the digital age.

www.oup.com/vsi

FUNDAMENTALISM
A Very Short Introduction
Malise Ruthven

Malise Ruthven tackles the polemic and stereotypes surrounding this complex phenomenon - one that eludes him today, a conclusion impossible to ignore since the events in New York on September 11 2001. But what does 'fundamentalism' really mean? Since it was coined by American Protestant evangelicals in the 1920s, the use of the term 'fundamentalist' has expanded to include a diverse range of radical conservatives and ideological purists, not all religious. Ruthven investigates fundamentalism's historical, social, religious, political, and ideological roots, and tackles the polemic and stereotypes surrounding this complex phenomenon - one that eludes simple definition, yet urgently needs to be understood.

'...powerful stuff...this book is perceptive and important.'

Observer

www.oup.com/vsi

GEOPOLITICS
A Very Short Introduction
Klaus Dodds

In certain places such as Iraq or Lebanon, moving a few feet either side of a territorial boundary can be a matter of life or death, dramatically highlighting the connections between place and politics. For a country's location and size as well as its sovereignty and resources all affect how the people that live there understand and interact with the wider world. Using wide-ranging examples, from historical maps to James Bond films and the rhetoric of political leaders like Churchill and George W. Bush, this Very Short Introduction shows why, for a full understanding of contemporary global politics, it is not just smart - it is essential - to be geopolitical.

'Engrossing study of a complex topic.'

Mick Herron, Geographical.

www.oup.com/vsi

LEADERSHIP
A Very Short Introduction
Keith Grint

In this *Very Short Introduction* Keith Grint prompts the reader to rethink their understanding of what leadership is. He examines the way leadership has evolved from its earliest manifestations in ancient societies, highlighting the beginnings of leadership writings through Plato, Sun Tzu, Machiavelli and others, to consider the role of the social, economic, and political context undermining particular modes of leadership. Exploring the idea that leaders cannot exist without followers, and recognising that we all have diverse experiences and assumptions of leadership, Grint looks at the practice of management, its history, future, and influence on all aspects of society.

www.oup.com/vsi

MODERNISM
A Very Short Introduction
Christopher Butler

Whether we recognise it or not, virtually every aspect of our
life today has been influenced in part by the aesthetic legacy
of Modernism. In this *Very Short Introduction* Christopher Butler
examines how and why Modernism began, explaining what
it is and showing how it has gradually informed all aspects of
20th and 21st century life. Butler considers several aspects
of modernism including some modernist works; movements
and notions of the avant garde; and the idea of 'progress' in art.
Butler looks at modernist ideas of the self, subjectivity,
irrationalism, people and machines, and political definitions
of modernism as a whole.

RACISM
A Very Short Introduction
Ali Rattansi

From subtle discrimination in everyday life and scandals in politics, to incidents like lynchings in the American South, cultural imperialism, and 'ethnic cleansing', racism exists in many different forms, in almost every facet of society. But what actually is race? How has racism come to be so firmly established? Why do so few people actually admit to being racist? How are race, ethnicity, and xenophobia related? This book reincorporates the latest research to demystify the subject of racism and explore its history, science, and culture. It sheds light not only on how racism has evolved since its earliest beginnings, but will also explore the numerous embodiments of racism, highlighting the paradox of its survival, despite the scientific discrediting of the notion of 'race' with the latest advances in genetics.

www.oup.com/vsi

ANTISEMITISM
A Very Short Introduction
Steven Beller

Antisemitism - a prejudice against or hatred of Jews - has been a chillingly persistent presence throughout the last millennium, culminating in the dark apogee of the Holocaust. This *Very Short Introduction* examines and untangles the various strands of antisemitism seen throughout history, from medieval religious conflict to 'new' antisemitism in the 21st century. Steven Beller reveals how the phenomenon grew as a political and ideological movement in the 19th century, how it reached it its dark apogee in the worst genocide in modern history - the Holocaust - and how antisemitism still persists around the world today.

www.oup.com/vsi

INTERNATIONAL RELATIONS
A Very Short Introduction
Paul Wilkinson

Of undoubtable relevance today, in a post-9-11 world of growing political tension and unease, this *Very Short Introduction* covers the topics essential to an understanding of modern international relations. Paul Wilkinson explains the theories and the practice that underlies the subject, and investigates issues ranging from foreign policy, arms control, and terrorism, to the environment and world poverty. He examines the role of organizations such as the United Nations and the European Union, as well as the influence of ethnic and religious movements and terrorist groups which also play a role in shaping the way states and governments interact. This up-to-date book is required reading for those seeking a new perspective to help untangle and decipher international events.

www.oup.com/vsi

KNOWLEDGE
A Very Short Introduction
Jennifer Nagel

What is knowledge? Is it the same as opinion or truth? Do you need to be able to justify a claim in order to count as knowing it?

Questions like these are ancient ones, and the branch of philosophy dedicated to answering them—epistemology—has been active for thousands of years.

In this thought provoking *Very Short Introduction*, Jennifer Nagel considers the central problems and paradoxes in the theory of knowledge whilst drawing attention to the ways in which philosophers and theorists have responded to them. She incorporates methods from logic, linguistics, and psychology, and uses a number of everyday examples to demonstrate the key issues and debates.

CRITICAL THEORY
A Very Short Introduction
Stephen Eric Bronner

In its essence, Critical Theory is Western Marxist thought with the emphasis moved from the liberation of the working class to broader issues of individual agency. Critical Theory emerged in the 1920s from the work of the Frankfurt School, the circle of German-Jewish academics who sought to diagnose--and, if at all possible, cure--the ills of society, particularly fascism and capitalism. In this book, Stephen Eric Bronner provides sketches of famous and less famous representatives of the critical tradition (such as George Lukács and Ernst Bloch, Theodor Adorno and Walter Benjamin, Herbert Marcuse and Jurgen Habermas) as well as many of its seminal texts and empirical investigations.

www.oup.com/vsi